T0333369

PROTEST

PROTEST

BRITAIN ON THE MARCH

mirrorpix

The History Press

All images are available to purchase from
www.vintagephotosonline.co.uk

Cover illustrations: *Front:* Police fighting with a woman on
Blackfriars Bridge Road during the 'Black People's Day of
Action'. *Back:* Pickets and Police clash at Daw Mill Colliery.

First published 2019

The History Press
97 St George's Place,
Cheltenham, GL50 3QB
www.thehistorypress.co.uk

British Library Cataloguing in Publication Data.
A catalogue record for this book is available from the British Library.

ISBN 978 0 7509 9072 1

Typesetting and origination by The History Press
Printed in Turkey by Imak

INTRODUCTION

Article 19.
Everyone has the right to freedom of opinion and expression; this right includes freedom to hold opinions without interference and to seek, receive and impart information and ideas through any media and regardless of frontiers.

Article 20.
(1) Everyone has the right to freedom of peaceful assembly and association.

The Universal Declaration of Human Rights

Freedom of speech is rightly regarded as a central human right to any civilised and democratic society. It is natural that not everyone in a society, or even a single community, will agree on all issues, but it is when governments stray too far from the people's own ideas of the correct handling of a situation – be it war, the environment, civil rights or working practices – that they step out to make sure their voices are heard.

There is a long history of protest in the UK across a host of matters, and here, using Mirrorpix's impressive archive, we are able to see powerful photographs of Britain on the march for what it believes in. Sometimes the subjects are contentious, such as the recent Brexit protests, while other times they represent the next hurdle towards progress, such as the anti-Clause 28 marches. Although peaceful protest, usually involving organised marches, is the norm – and much preferred to violent action – these images also show how sometimes deeply personal and strongly felt issues can give rise to such anarchic behaviour as looting or physical violence.

From the suffragettes to the March4Women campaigners, the anti-Suez demonstrations to the anti-war protests of the twenty-first century, and the Young Socialists' march against racialism in the 1960s to the Black Lives Matter movement of today, the points at issue are often the same, but if every march – every voice added – creates progress and moves British society forward, then the nation should be proud to rise to what it believes in for the benefit of all.

THE SUEZ CRISIS

On 26 July 1956, Egypt's President Nasser nationalised the Suez Canal – a move that was wholly unexpected by Britain. British Prime Minister Anthony Eden was advised that this was Nasser's *Mein Kampf*, and that he should strike fast and decisively in response. After a coalition was formed with Israel and France, and following Israel's invasion of Egypt on 29 October, France and the UK issued an ultimatum to cease fire. Their command ignored, the two countries joined their ally by landing para-troopers along the Suez Canal. Although it was supported by a majority in the UK at the time, there were many who objected to the warmongering and took to the streets to protest.

Just over a week later, on 7 November, pressure from the US, the USSR and the United Nations led to a full withdrawal from the area. It was a political defeat for the UK and led, ultimately, to the resignation of Anthony Eden.

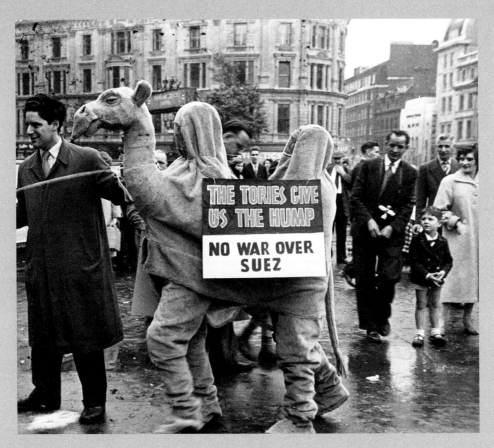

▲ 23 August 1956. A stage camel makes a useful prop in a protest over the Suez situation.

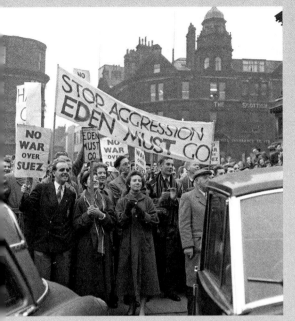
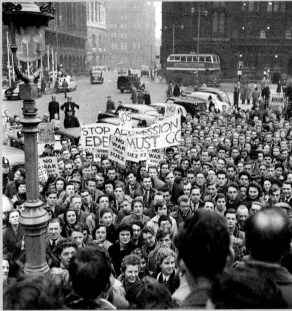

▲ 1 November 1956. Students from Manchester University demonstrate against British policy in Egypt during the Suez Crisis.

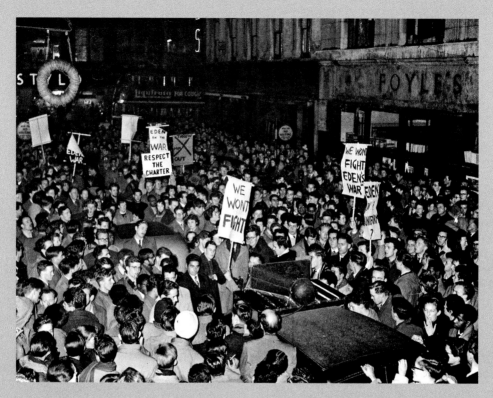

▲ November 1956. Demonstrators hostile to the government's Egypt policy protest in the streets of Central London.

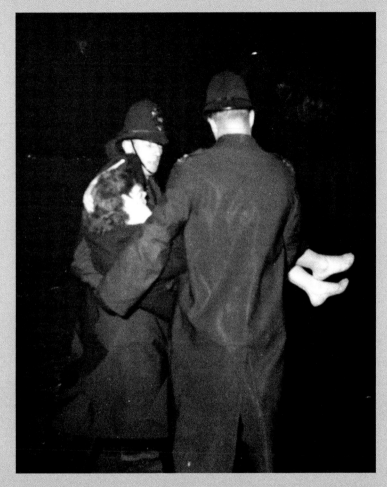

▲ 5 November 1956. An anti-war demonstration in Trafalgar Square, London.

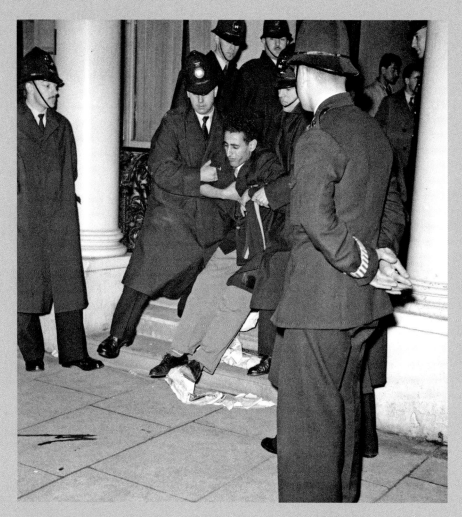

▲ 5 November 1956. Arab students stage a sit-down protest at the Iraq Embassy in London, angry at Iraq's failure to stop oil supplies to Britain and its refusal to give military aid to Egypt.

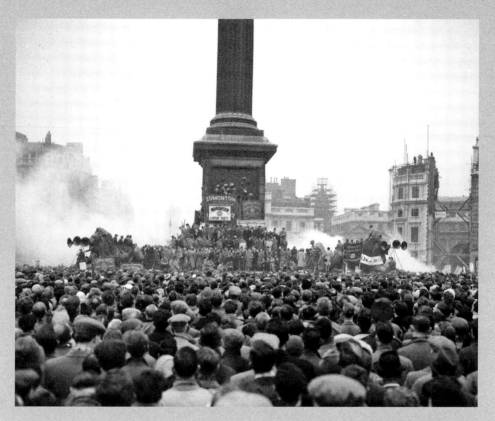

▲ November 1956. Campaigners rally against war and the Suez Crisis in Trafalgar Square, London.

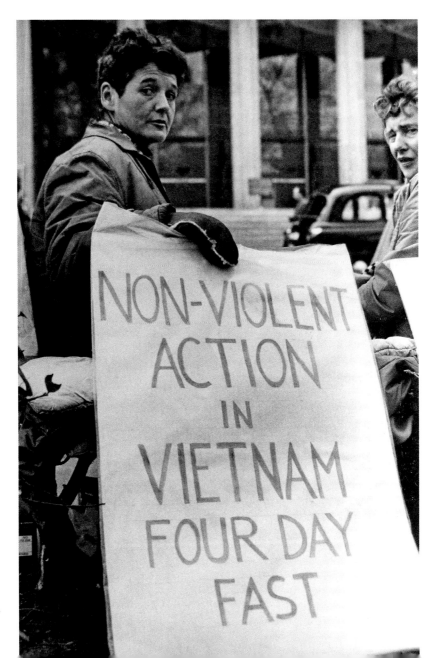

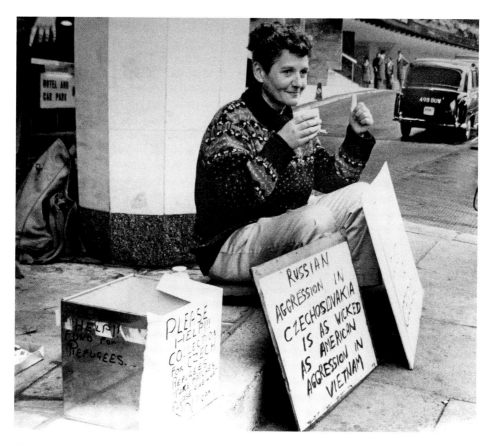

▲ 30 August 1968. Pat Arrowsmith sitting on the kerb with collection money outside the Russian Embassy, during a seven-day protest and fast against the Russian occupation of Czechoslovakia.

◄ March 1968. Pacifist campaigner Pat Arrowsmith on a four-day fast in a protest against the Vietnam War, sitting outside the US Embassy in London.

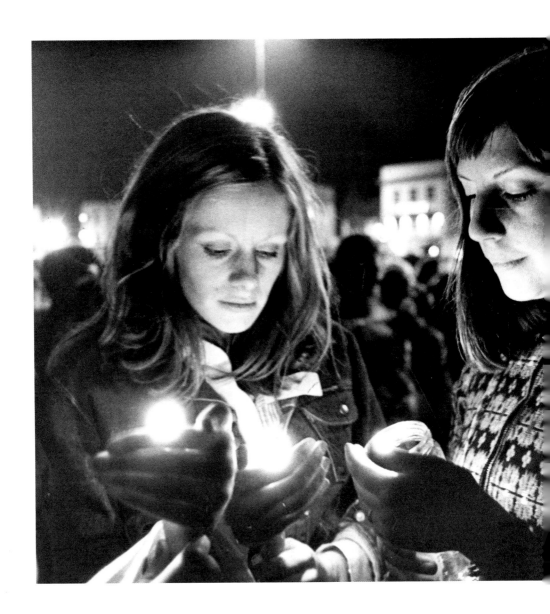

◀ 15 December 1980. Pat Doherty (left) and Chris Jemmison at the Liverpool candlelight vigil for peace, in the wake of John Lennon's murder.

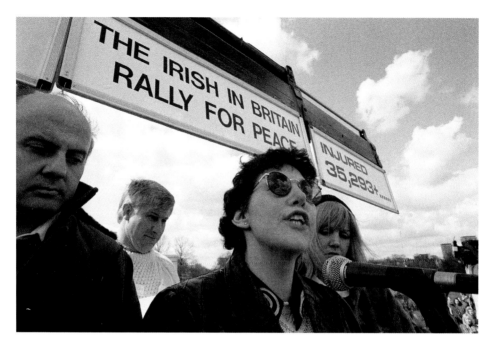

▲ 4 April 1993. Susan McHugh, Irish peace campaigner, addresses a crowd at The Irish in Britain Rally for Peace, Hyde Park – a direct reaction to an IRA bomb attack in Warrington on 20 March, when two boys were killed by terrorists. The murder of two innocents was a step too far for many, who, by their silence, had supported the armed struggle.

Previously, McHugh, a housewife and mother living in Clontarf, Dublin, had organised a protest meeting at Trinity College, Dublin, which 1,000 people attended. 'The IRA did not kill Johnathan Ball in my name or in your name. I want to tell the world tonight they did not kill him in the name of Ireland.' She appealed to politicians of all parties on both sides of the border: 'We demand an immediate peace plan ... tonight is a night to remember. We, the silent majority, say enough is enough.'

➤➤ 4 April 1993. The Irish Freedom Movement attempts to hijack The Irish in Britain Rally for Peace.

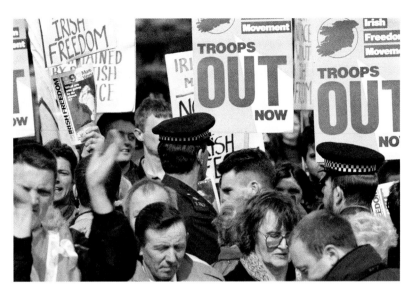

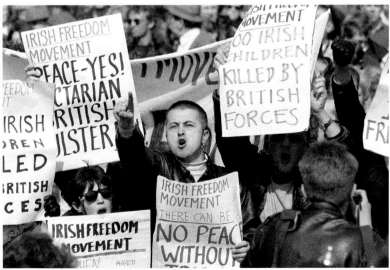

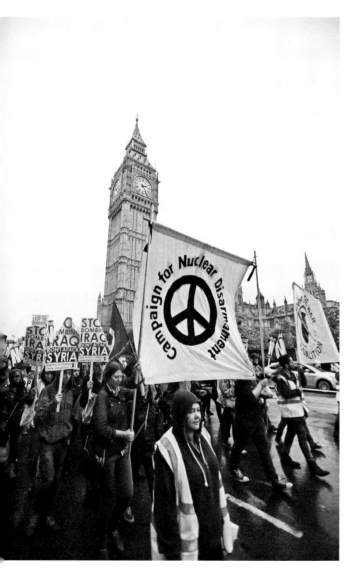
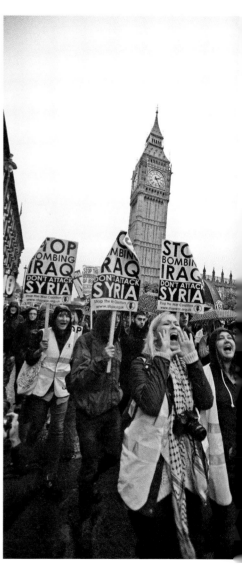

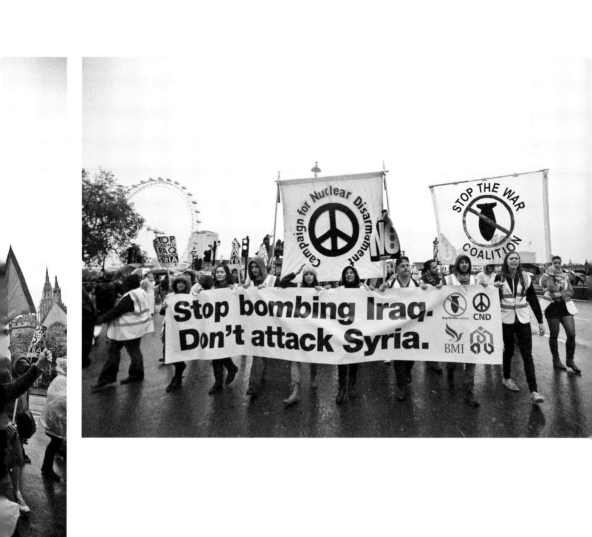

◄▲ 4 October 2014. Anti-war demonstrators march to Downing Street following news that the UK will commit military strikes against ISIS.

THE RHODESIA QUESTION

After the Second World War, the world began to change. Britain was left bankrupt and unable to subsidise its colonies (not to mention the colonies themselves were beginning to rise up and resist). The Suez Crisis made the sitation worse: Britain's complete failure on the world stage showed that they were no longer the superpower they once had been and a process of 'decolonisation' began. The sun was setting on the British Empire.

This terrified the white minority in Southern Rhodesia, which had been self-governing since 1923. Although they only accounted for around 5 per cent of the population, the government was mostly white and they were reluctant to lose control to the black majority. Southern Rhodesia declared independence in 1965, but it wasn't until 1970 – after talks with Britain had completely broken down – that it declared itself the Republic of Rhodesia. The UN called it 'an illegal racist minority regime'.

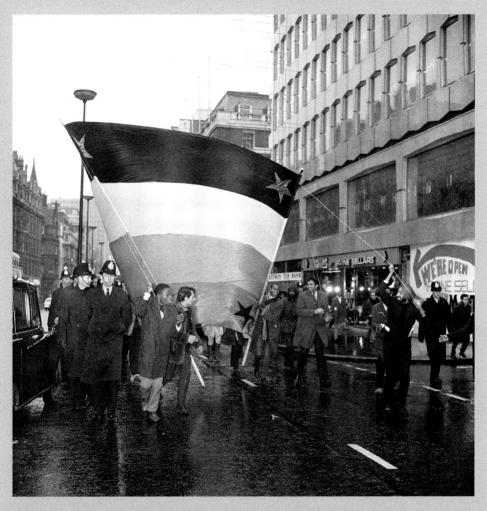

▲ 12 January 1969. Anti-Rhodesia (now Zimbabwe) marches in London join forces. While about 2,000 people left Hyde Park Corner behind the banner of the Black People's Alliance, a further 1,000 or so march behind the anti-Rhodesian flag.

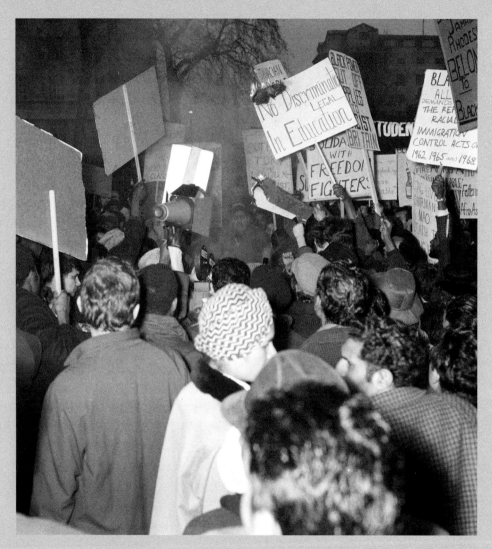

▲▶ 12 January 1969. Demonstrators in Whitehall, London, with some of the posters on fire.

THE RHODESIA QUESTION

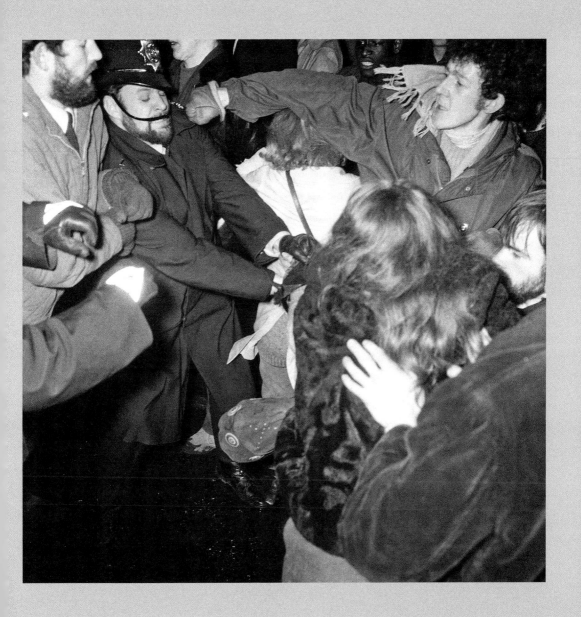

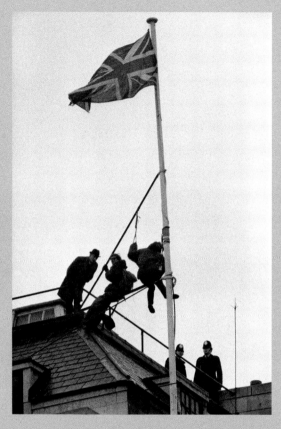

▲ 12 January 1969. Two men in mountaineers' kit on the flagpole on top of Rhodesia House in London. They climbed the pole at midnight, took down the Rhodesian flag, replaced it with the Union Jack and told police officers who tried to get them down that they were staying put until the afternoon demonstration on the 12th. At 10 a.m. they had sandwiches whilst still on the flagpole and afterwards one of them read a book.

➤➤ 12 January 1969. Scenes outside Rhodesia House.

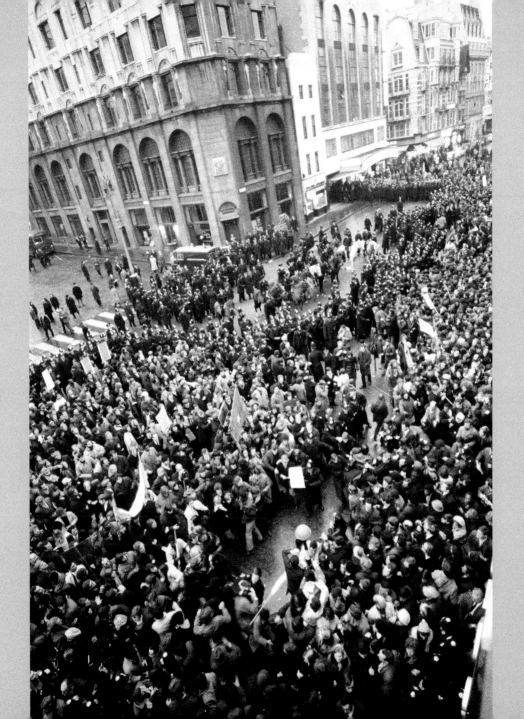

➤ 16 October 1993. The Anti-Nazi League riot during a protest against the British National Party (BNP) at their headquarters in Welling, south-east London.

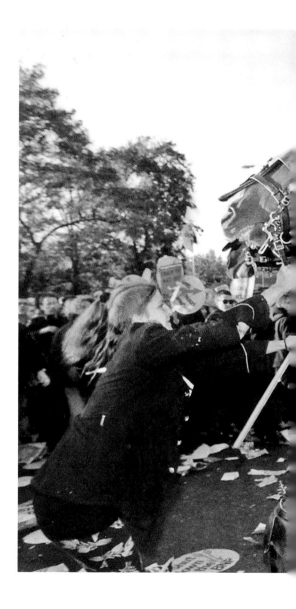

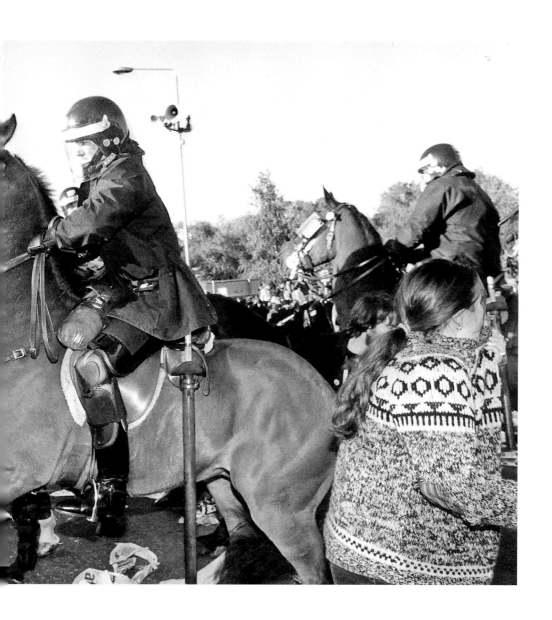

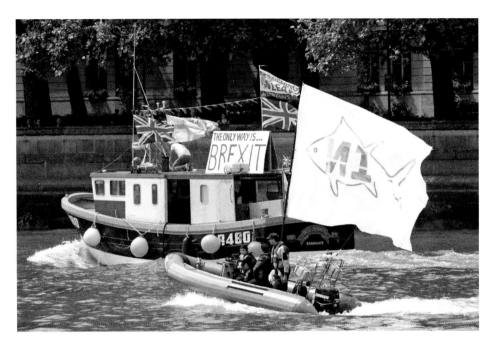

▲ 15 June 2016. The so-called 'Battle of the Thames'. A Leave-supporting fisherman sprays water at a Remain-supporting boat in the 'Fishing for Leave' flotilla that is protesting in favour of a 'Leave' vote in the EU Referendum.

➤ 24 June 2016. University of the Arts London student Marta Dunjo protests Brexit opposite the Houses of Parliament as the press gathered on the day of the Brexit referendum result, in which Britain voted to leave the EU.

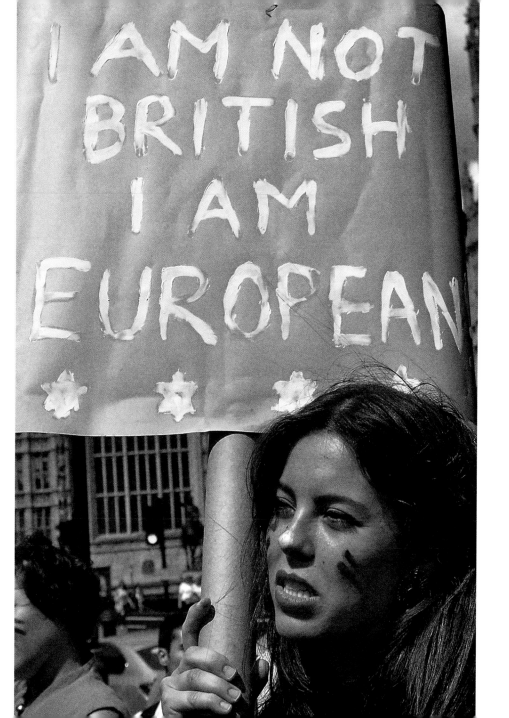

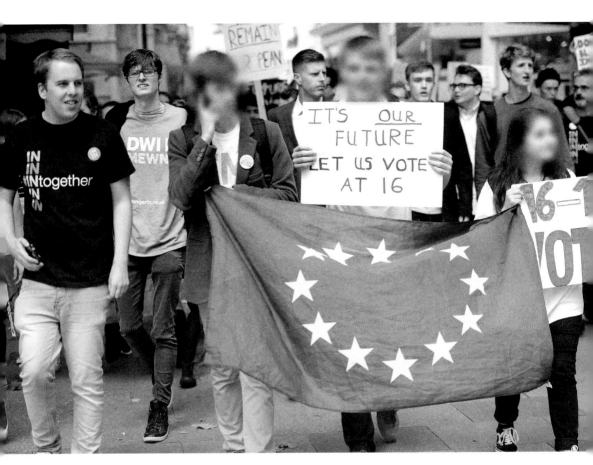

▲ 27 June 2016. Remain campaigners walk through Cardiff asking for votes at 16, after the Leave result in the referendum – a result that might not have happened if 16- and 17-year-olds had been allowed to vote.

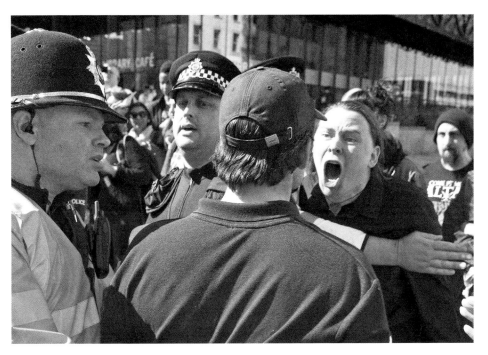

⌃ 8 April 2017. An English Defence League (EDL) demonstration in Birmingham.

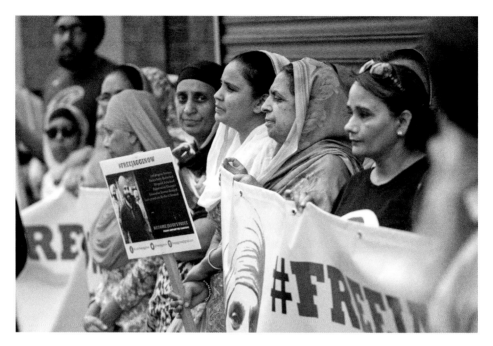

▲▶ 23 July 2018. The campaign for the release of Briton Jagtar Singh Johal took to the streets of Birmingham, with a protest at the Indian Consulate.

Hundreds of mostly Sikh protesters chanted and made calls for the Indian authorities to set Mr Johal free. Mr Johal, 31 from Dumbarton, was seized by Indian security forces on 4 November 2017 while in the country to get married. Protesters claimed he was arrested on trumped-up allegations and said he had been tortured daily. The Indian security services accused Mr Johal of plotting terrorist attacks in Punjab, but by the date of the protest he had been detained for 300 days without charge.

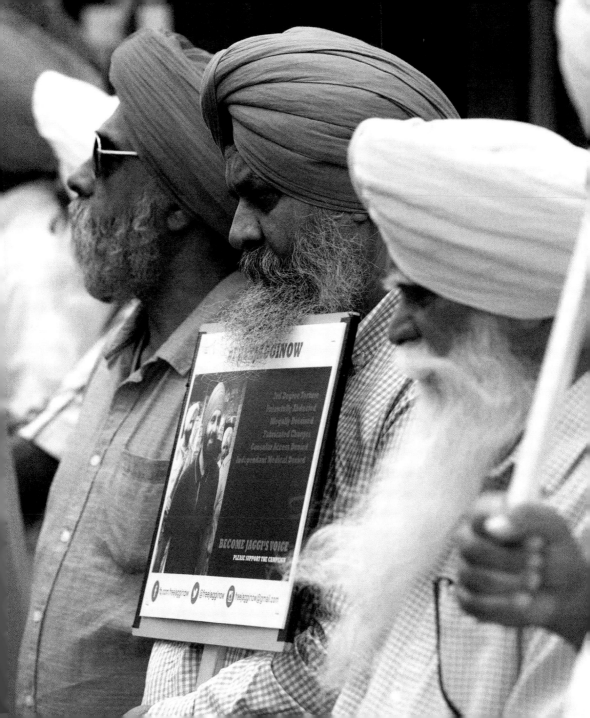

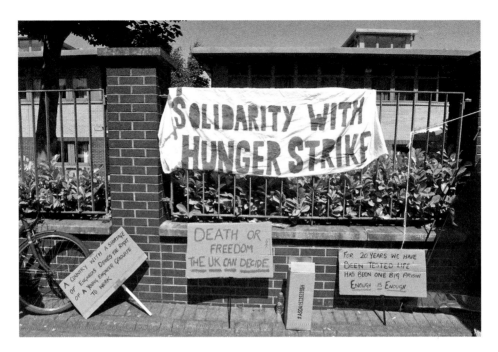

▲ 28 June 2018. Placards supporting a hunger-striking Iraqi Kurd family outside the Glasgow Immigration Office. After eighteen years of uncertain legal status, the family were granted permission to remain in the country in July 2018.

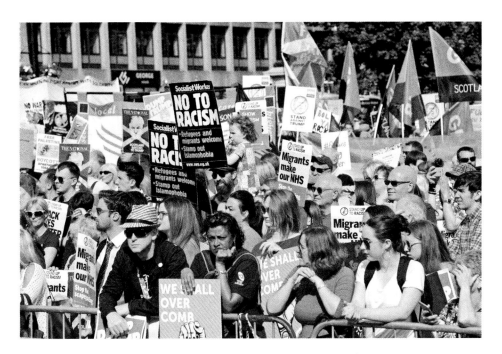

▲ 13 July 2018. An anti-Donald Trump protest in George Square, Glasgow.

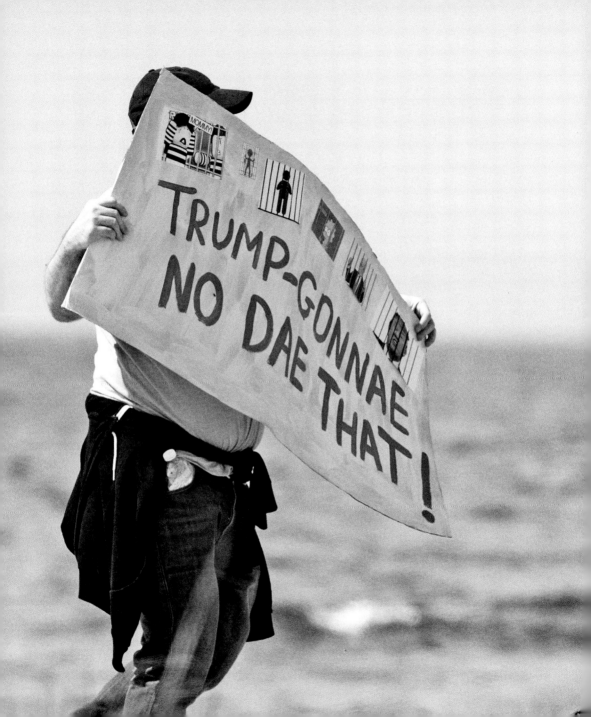

◄ 14 July 2018.
President Donald Trump
protesters at the beach,
ahead of him playing
the Ailsa course at his
Trump Turnberry resort
in South Ayrshire.

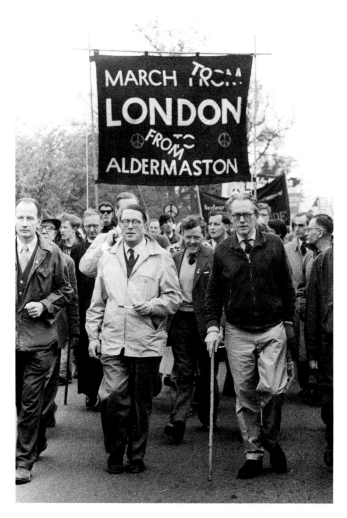

▲ 31 March 1961. A march from Aldermaston to London in support of disarmament.

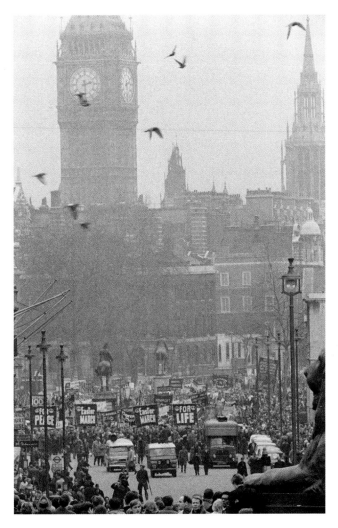

∧ 30 March 1964. The Campaign for Nuclear Disarmament (CND) Easter rally, Trafalgar Square, London.

▲➤ 16 July 1983. A CND demonstration in Hyde Park, London.

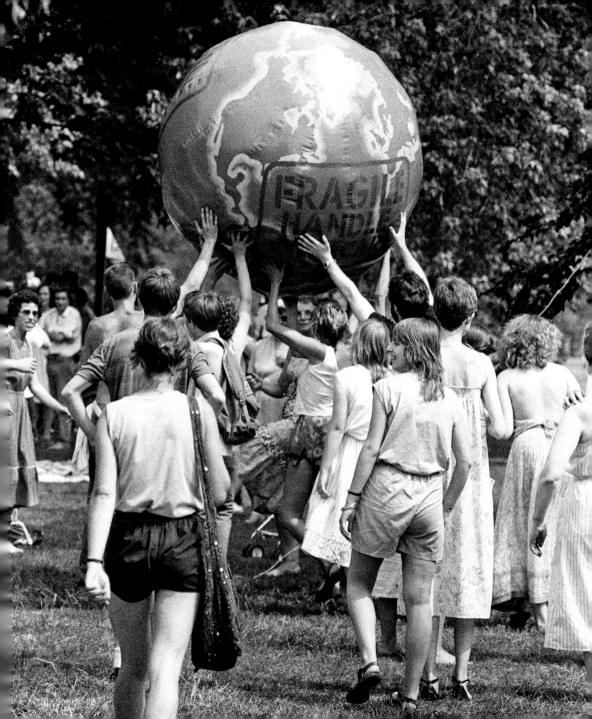

➤➤ 26 May 1984. CND protesters listen to a speaker at the War Memorial Park in Kenilworth, Warwickshire, following a march.

Coventry was reduced to chaos as tens of thousands of marchers took part in a ban-the-bomb rally. Anti-nuclear protesters from all over the country arrived in the city to take part in marches. Massive disruption was expected, as many city streets were cut off and bus services thrown into chaos. A collossal police operation was launched, masterminded from a city-centre control room, with 200 officers stationed along the routes of the marches and extra police drafted in to Coventry from other parts of the West Midlands to control the crowds.

The campaigners marched from Edgwick Park, Gosford Green and Hearsall Common at noon, in a route that formed the CND symbol. The processions converged at about 1 p.m. on Coventry Cathedral and then marched south to War Memorial Park for a rally. Speakers at the rally included Monsignor Bruce Kent, General Secretary of CND; Joan Ruddock, Chair of CND; Professor E.P. Thompson, historian and prominent CND campaigner; and Lynne Jones, a representative from the Greenham Common women's camp. Police had been told to expect up to 50,000 demonstrators, but CND organisers thought the number was less than half that, due to the bad weather and the timing of the march, which was two weeks before another rally in London.

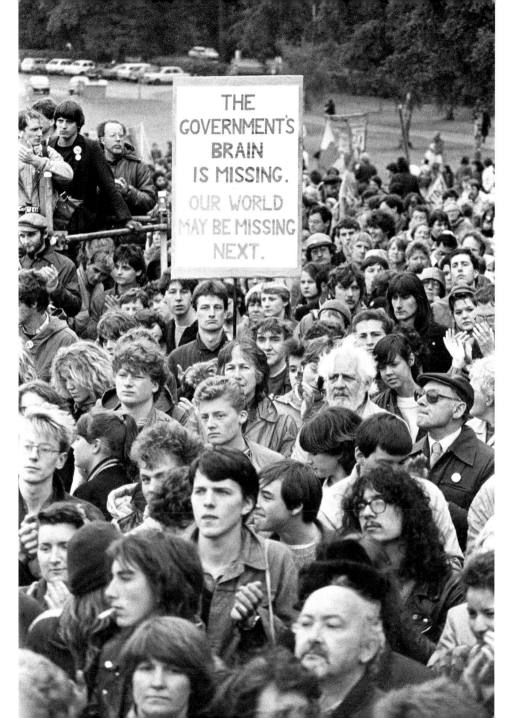

▲ January 1986. Henrietta Miller, covered with sticky 'anti-climb' paint, is carried out with an injured hip during protests against Carmarthen District Council's nuclear bunker.

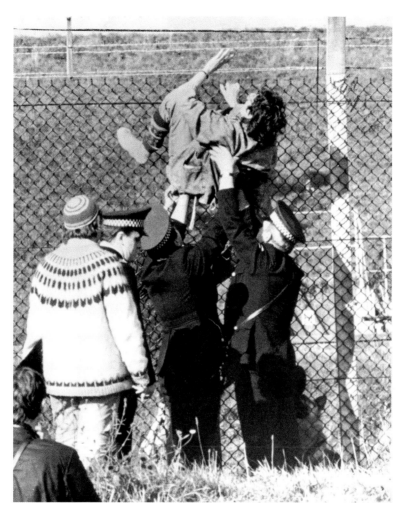

⌃ 16 October 1988. The long arm of the law reaches out to stop a woman scaling a fence at a CND protest against HMNB *Clyde,* Faslane, the UK's nuclear submarine base.

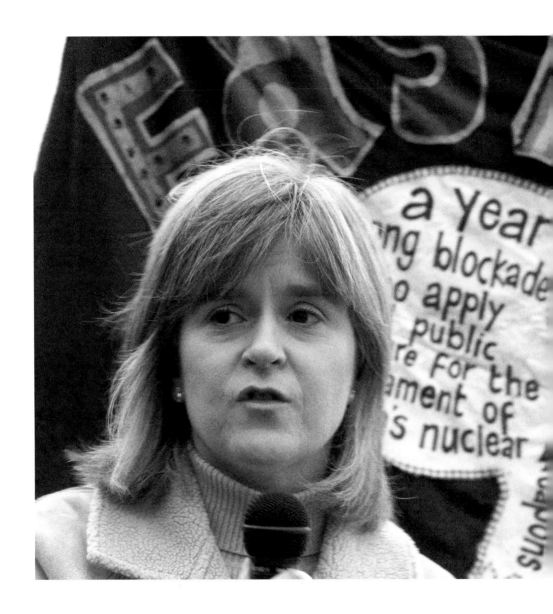

◄ January 2007. Nicola Sturgeon MSP during a protest against nuclear weapons at Faslane.

GREENHAM COMMON WOMEN'S PEACE CAMP

On 5 September 1981 a Welsh group called 'Women for Life on Earth' arrived at Greenham to protest against the decision of the government to allow ninety-six American cruise missiles to be based at RAF Greenham Common. After their request for a debate on the issue was ignored, they were joined by women of the Berkshire Anti-Nuclear Campaign; a nineteen-year occupation that would become known as the 'Women's Peace Camp' began.

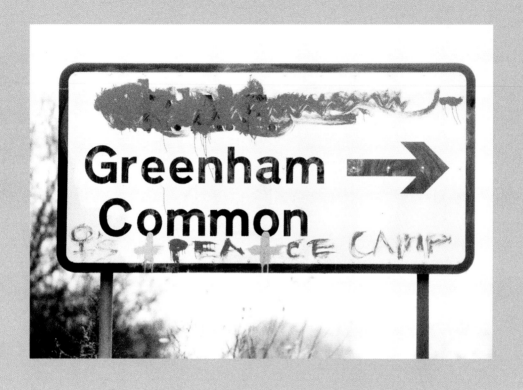

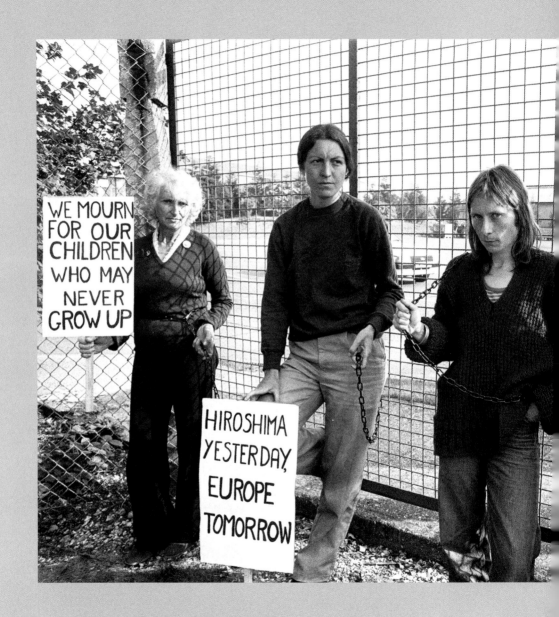

Text on signs within image:
WE MOURN FOR OUR CHILDREN WHO MAY NEVER GROW UP

HIROSHIMA YESTERDAY, EUROPE TOMORROW

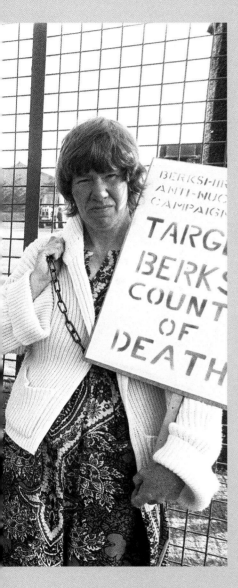

◀ 6 September 1981. Demonstrators chain themselves to the fence at the Women's Peace Camp.

➤ 12 December 1982. Greenham Common protestors demonstrate against US cruise missiles.

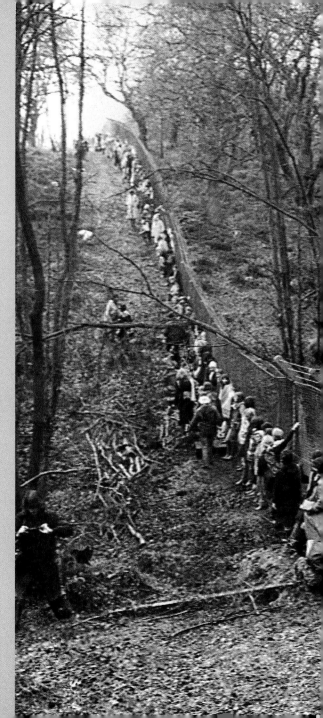

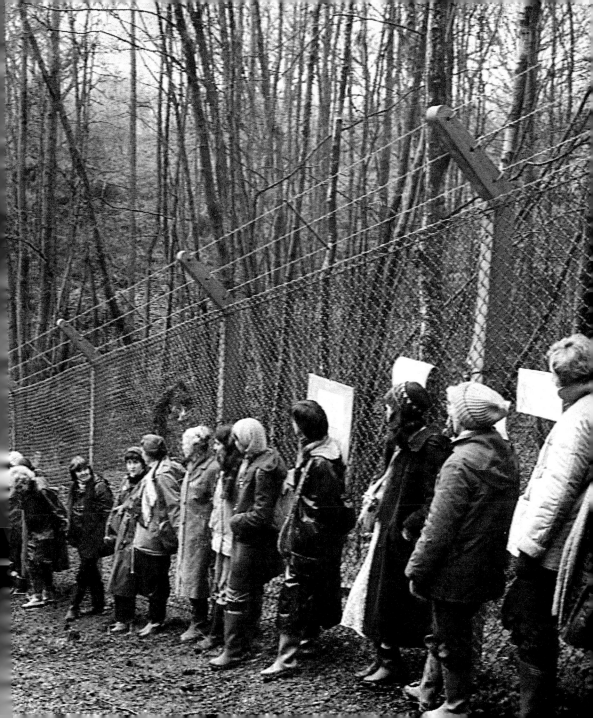

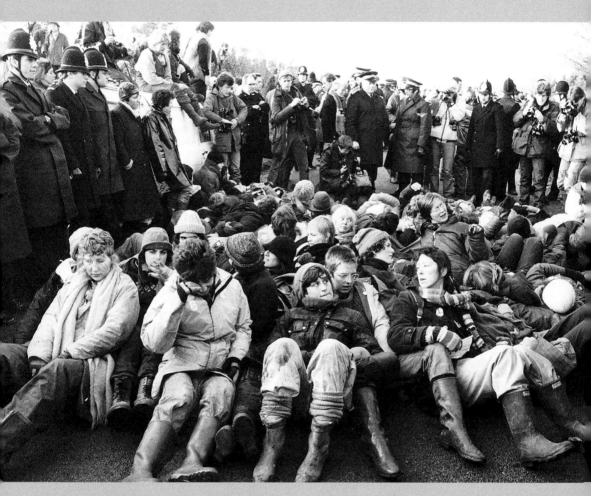

▲ 13 December 1982. Women sit at the gateway to RAF Greenham Common.

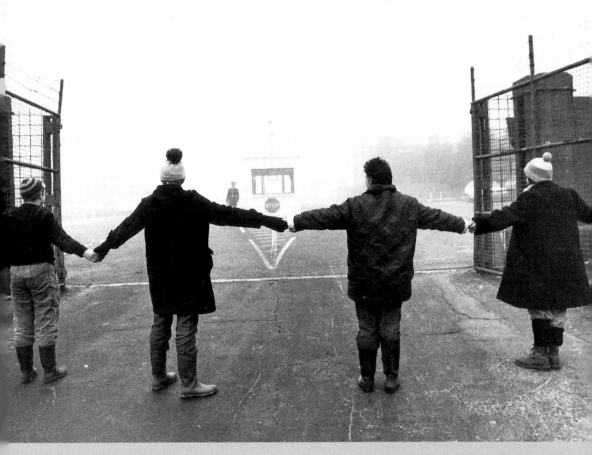

▲ 9 December 1982. CND women join hands outside Greenham Common nuclear airbase.

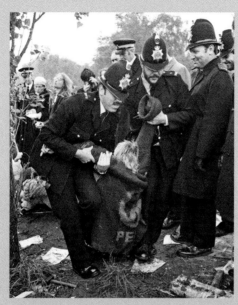

◄▼ 28 May 1982. Women's Peace Camp at RAF Greenham Common.

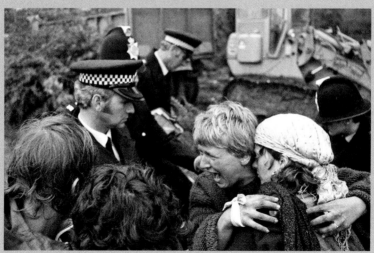

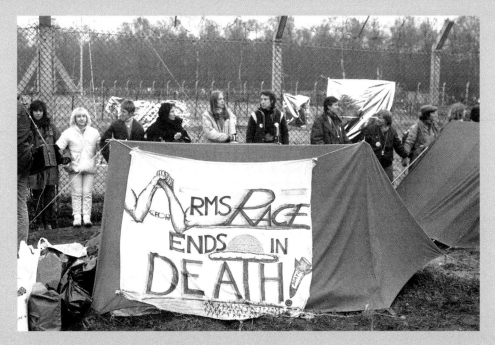

▲ 12 December 1983. Fifty thousand women converge on the Women's Peace Camp to link hands and encircle the airbase.

On 1 April 1983, 70,000 protesters converged on Greenham Common Women's Peace Camp and the Nuclear Weapons Establishment at Aldermarston to create a 14-mile human chain between the two bases in protest against the decision to site missiles at Greenham Common and the proliferation of nuclear weapons.

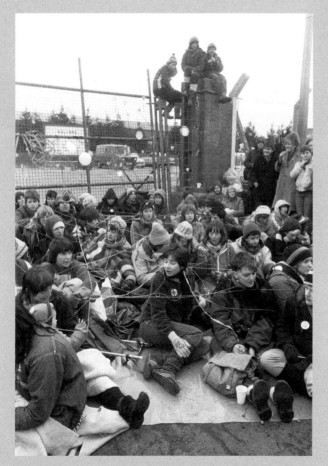

◄ Protesters block a gate at the airbase.

➤➤ A 14-mile human chain between the two bases to protest the decision to site missiles at Greenham Common and the proliferation of nuclear weapons.

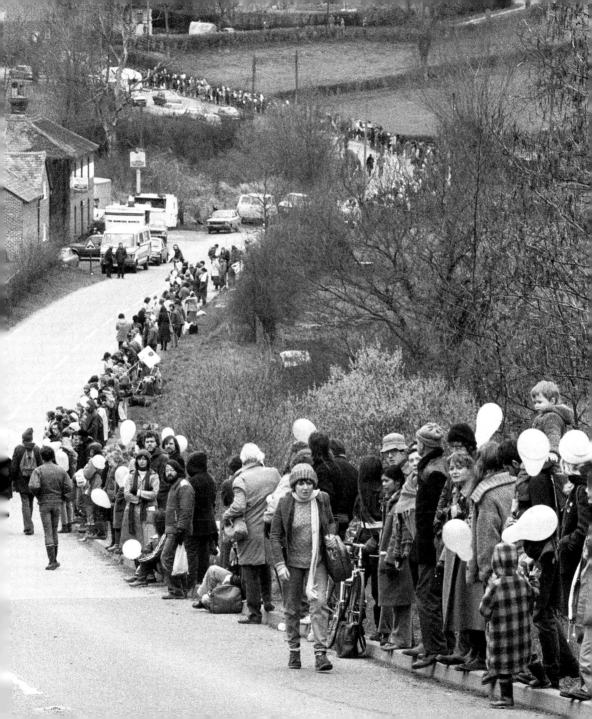

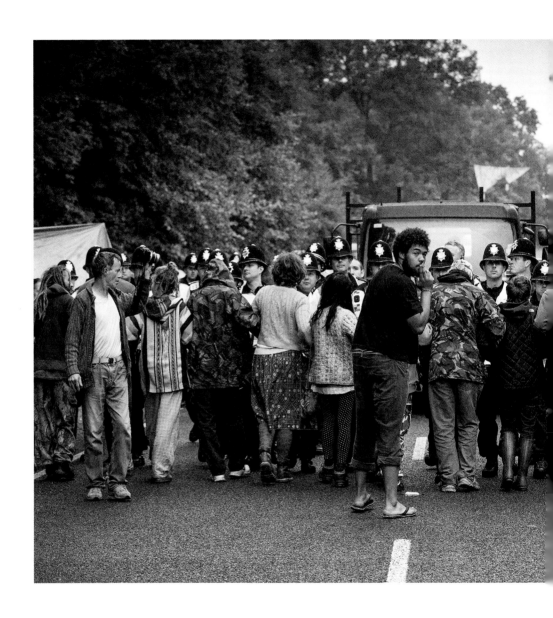

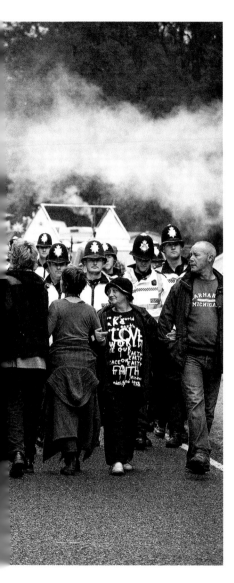

◀ 9 September 2013. Anti-fracking (hydraulic fracturing) protesters at the Cuadrilla exploration site in Balcombe, West Sussex, where the oil and gas exploration firm resumed drilling for shale gas following a complaint by local residents of excessive noise levels a week earlier. Protesters at the site were visited by officers from West Sussex County Council, who carried out a risk assessment of the site.

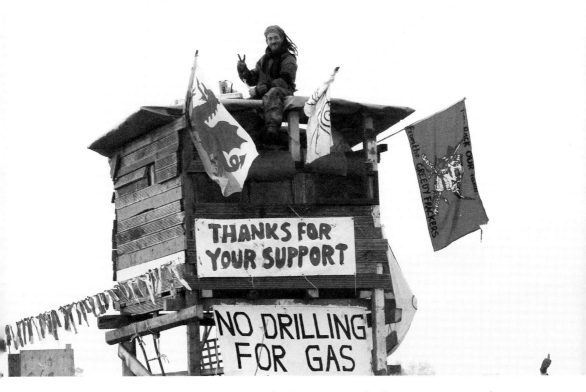

▲ 20 November 2014. Protestors outside the Borras anti-fracking camp near Wrexham during court proceedings in Manchester to evict them from the site.

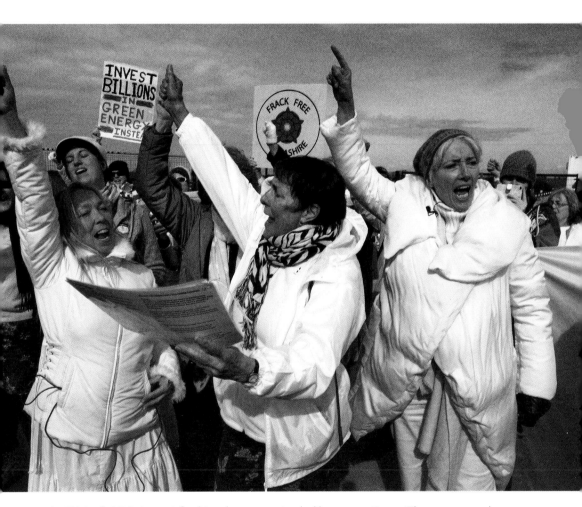

▲ 21 March 2018. An anti-fracking demonstration led by actress Emma Thompson marches on the tracking site of Little Plumpton, near Blackpool in Lancashire, which is run by energy firm Cuadrilla.

➤ 16 October 2018. Fashion designer Dame Vivienne Westwood, with her son Joseph Corré, campaigns with fellow anti-fracking protesters near the entrance to the Preston New Road drill site where Cuadrilla have commenced fracking operations to extract shale gas.

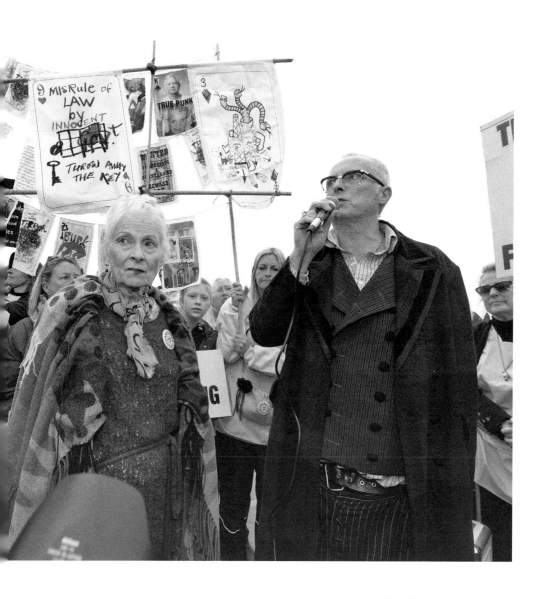

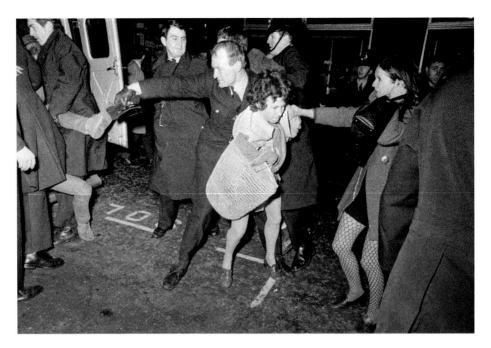

▲ 24 January 1969. London School of Economics (LSE) students demonstrating against the installation of steel security gates, which they claimed made the school look like a concentration camp. Police scuffle with student protestors following their eviction from the school.

➤➤ 19 February 1969. LSE students return to lectures in stylish defiance. They assembled in Lincoln's Inn to march down Kingsway towards the school. At the head of the column were a group of wigged and gowned student 'judges' carrying an effigy of LSE director Walter Adams.

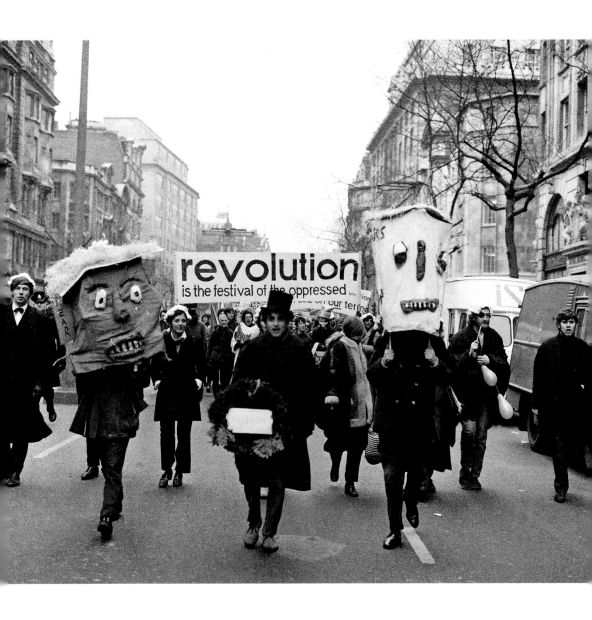

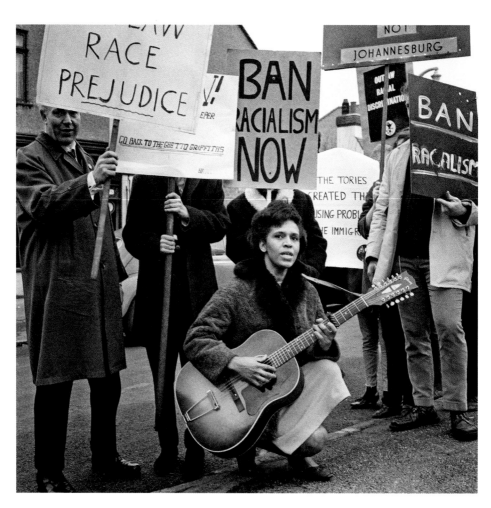

▲▶ 27 January 1965. Young Socialists demonstrate at a meeting held by Conservative MP for Smethwick, Peter Griffiths, in Sutton, South London.

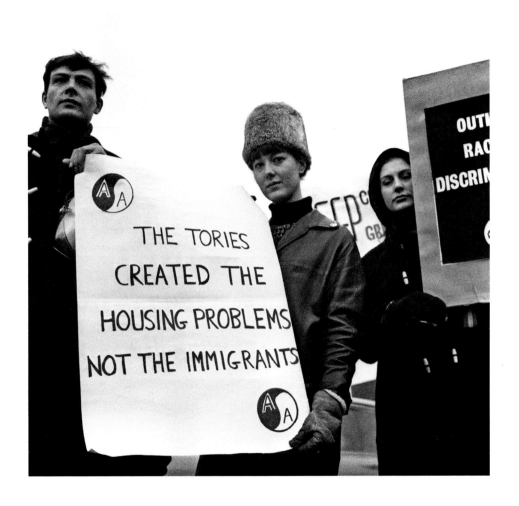

BLACK PEOPLE'S DAY OF ACTION

On 17 January 1981, the birthday party of 16-year-old Yvonne Ruddock ended in tragedy when a fire broke out, leaving thirteen young people dead. All of them were black. At the time, racial tension was high and the National Front was known to be active in Deptford. As the police investigation into the fire continued, the tension spread to breaking point, with the local community feeling that the investigation was becoming a whitewash and that it was avoiding what they believed was the real cause of the fire – arson.

This culminated with a 'Black People's Day of Action', where 20,000 people marched to Hyde Park in protest, but it turned violent after a 200-strong breakaway group attacked shops, wrecked cars and punched passers-by.

To this day, the cause of the fire has never been determined.

▶▶ The march comes out of the Elephant and Castle roundabout in Central London.

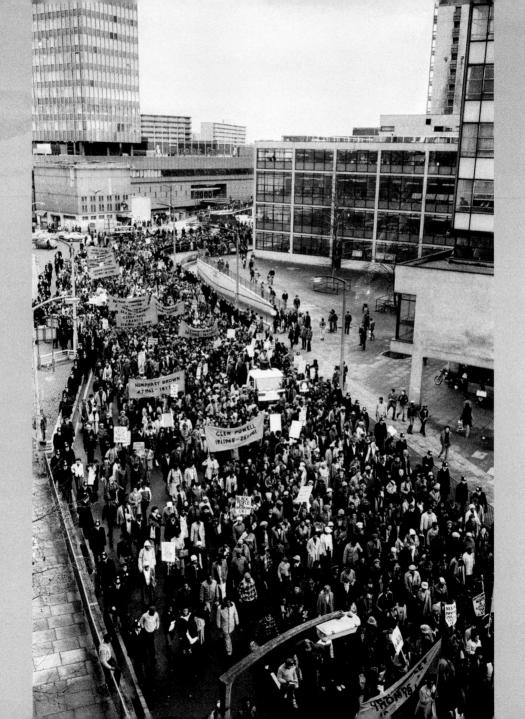

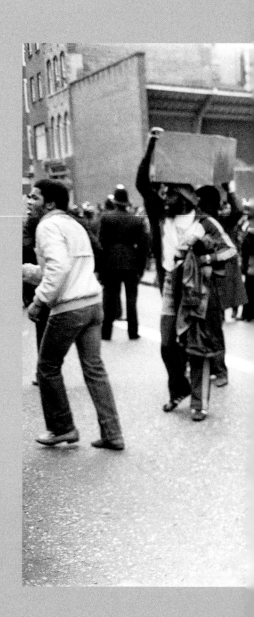

➤ An injured police officer after a clash with protesters in Blackfriars Bridge Road, London.

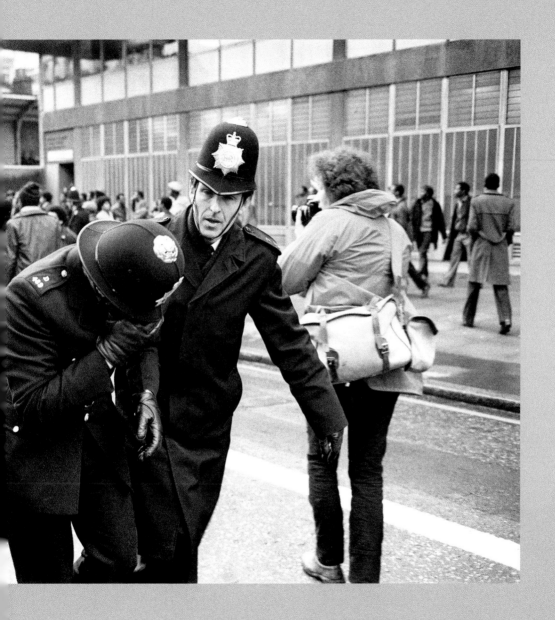

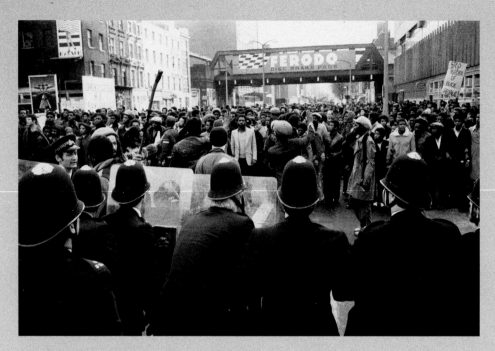

▲ Police with riot shields on Blackfriars Bridge Road.

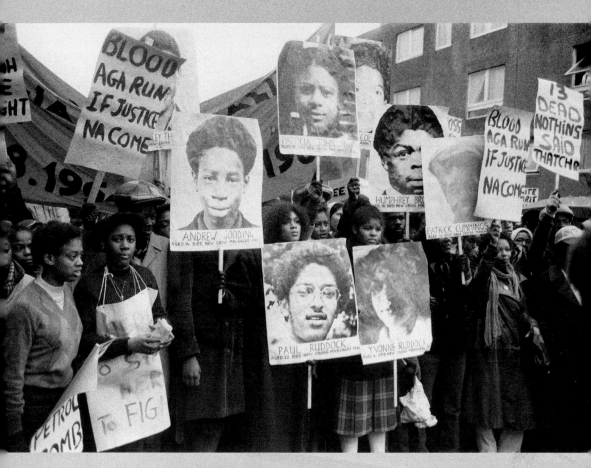

▲ Part of the peaceful march.

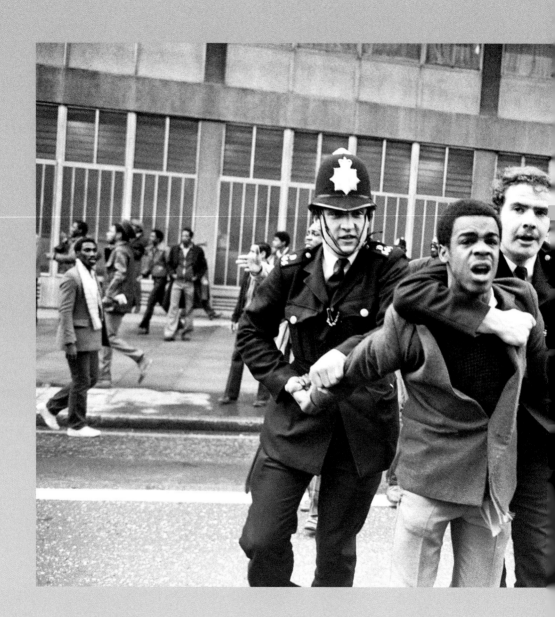

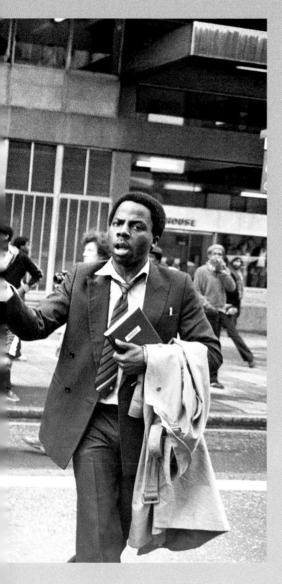

◀ Police making an arrest in Blackfriars Bridge Road.

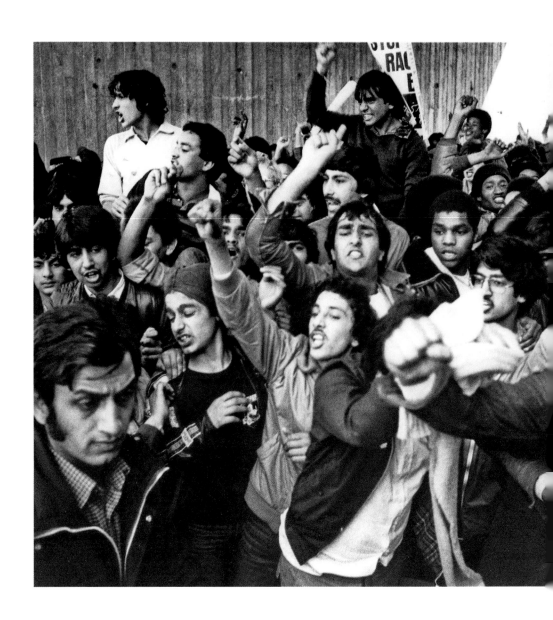

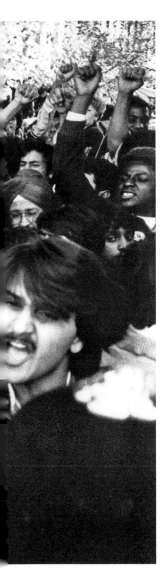

◄ (and overleaf) 23 May 1981. Some 8,000 people came to join the protest against racial prejudice and violence in Coventry – triggered by the murder of 20-year-old Satnam Singh Gill a few weeks earlier in a nearby shopping precinct. The mile-long procession was good-humoured as it threaded its way into the city centre from Edgwick Park. There were noisy chants and drums, but no clashes.

The trouble began as they approached Broadgate, where large numbers of skinheads lined the route. The skinheads threw missiles at the marchers, gave Nazi-style salutes and chanted 'Sieg Heil'. When the rally reached Cathedral Square, mounted police were sent into the crowd, which retaliated with rocks, sticks and bottles. Eleven police officers received minor injuries and seventy-four people were arrested.

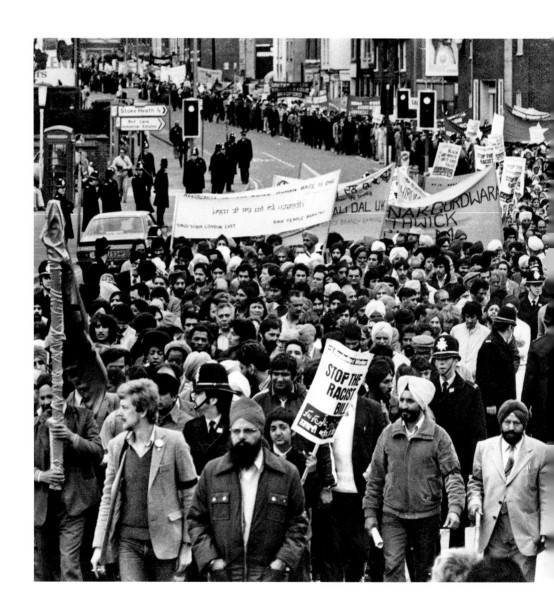

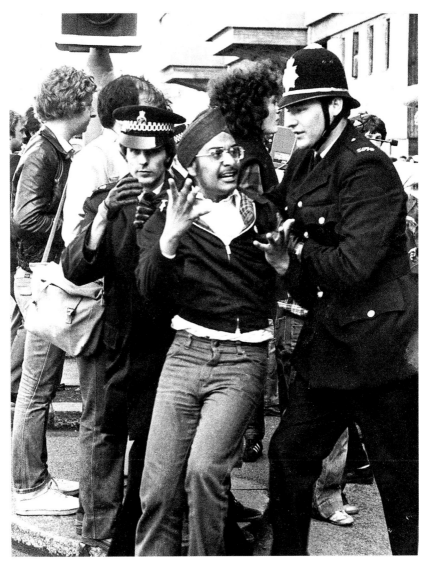

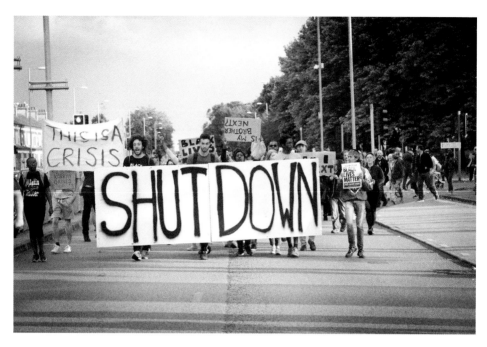

▲▶ 5 August 2016. People gather at Alexandra Park, Manchester, for a Black Lives Matter event to mark five years since the death of Mark Duggan, a 29-year-old mixed-race Londoner shot by police in 2011, and the subsequent England riots. Simultaneous events were held in Birmingham, London and Nottingham.

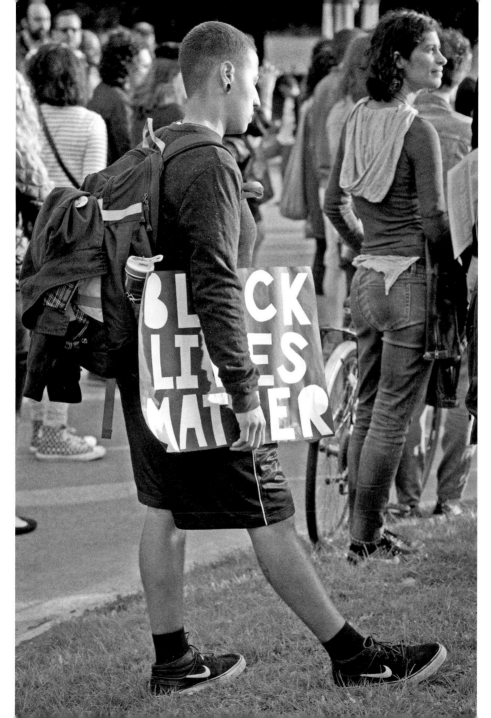

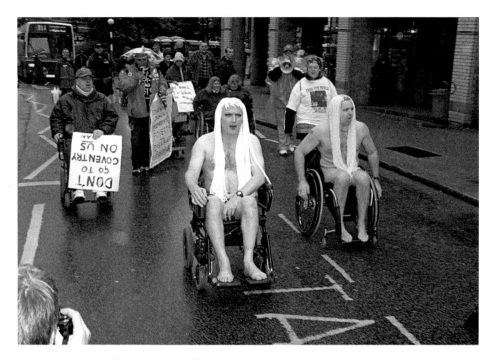

▲ 20 September 2001. Semi-naked campaigners stage a Lady Godiva-style protest against Coventry City Council's policy of charging disabled and elderly people for home-care services. Campaigners Robin Surgeon and Tom Cumerford sit in their wheelchairs in the lobby at the Council House, demanding to see council leader Cllr Nick Nolan.

The demonstration marked the launch of the Coventry Consultation Campaign, calling for a better deal for disabled people. Pensioners and disabled people assembled at Broadgate before marching to the Council House, where they piled into the lobby. They shouted slogans, demanded to see Cllr Nolan and refused to let anyone enter the building through the main entrance. Council officials told the protesters that Cllr Nolan was unavailable and eventually they agreed to a meeting with senior officials.

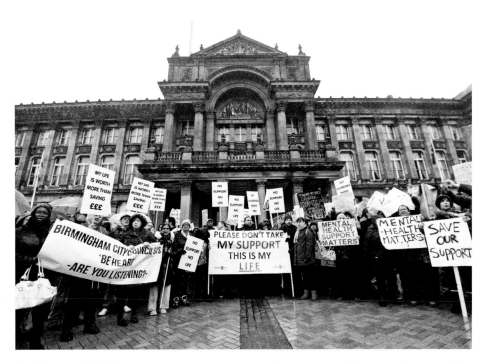

▲ 16 January 2017. Demonstrators protest over cuts in care to social-care services outside Birmingham Council House.

➤ 25 September 1971. The Festival of Light at Hyde Park, London, was part of a movement by British Christians to object to modern attitudes towards sex and sexuality, and mainstream media's portrayal of sex and violence.

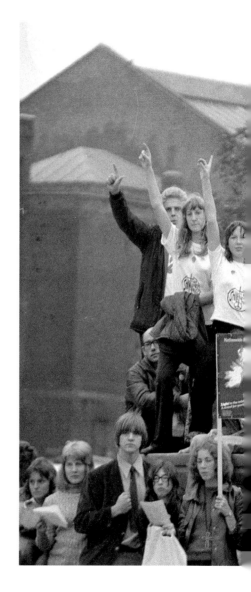

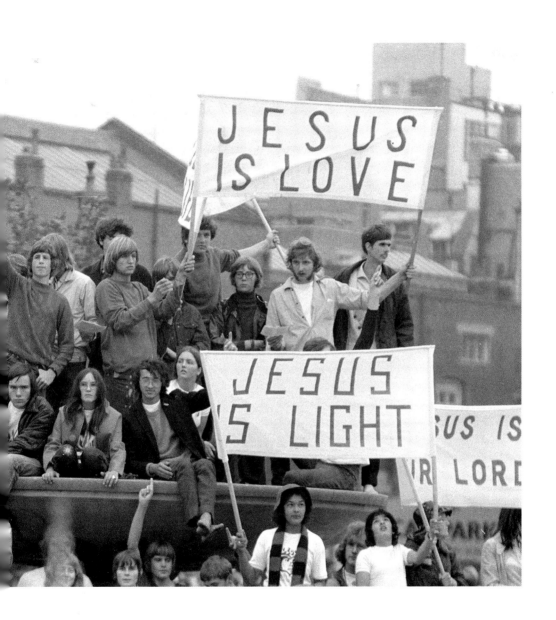

➤ 25 September 1971. Members of the Gay Liberation Front interrupt the Festival of Light and are arrested for causing a disturbance.

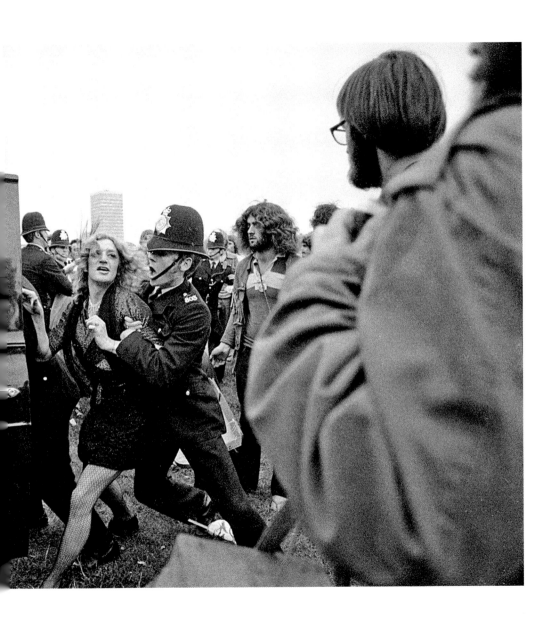

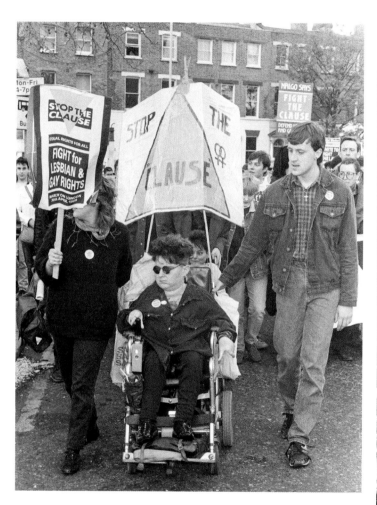

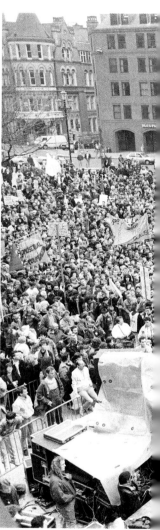

⋀ 30 April 1988. London LGBTQ activists and allies demonstrate against Clause 28 of the Local Government Act 1988, which states that a local authority 'shall not intentionally promote homosexuality or publish material with the intention of promoting homosexuality'.

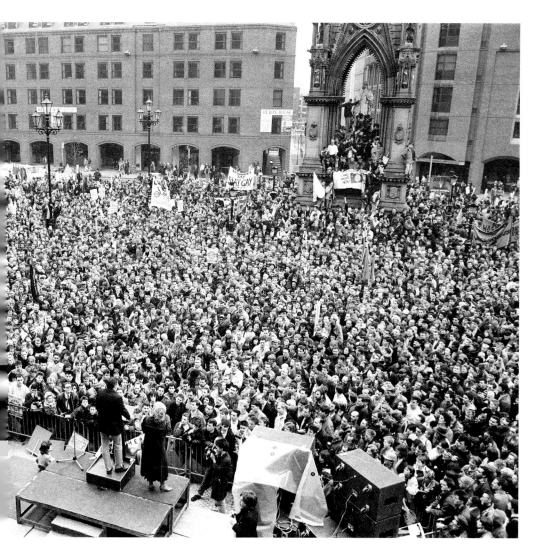

▲ 20 February 1988. Crowd scenes in protest of Clause 28 in Albert Square, Manchester.

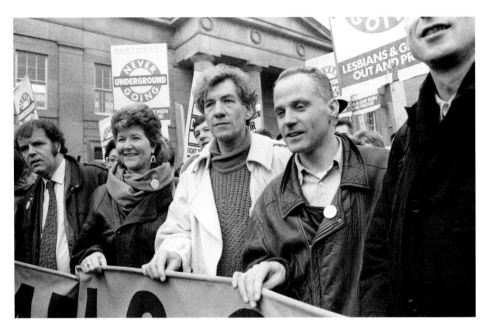

▲ 20 February 1988. Actors Michael Cashman and Ian McKellen at an anti-Clause 28 rally.

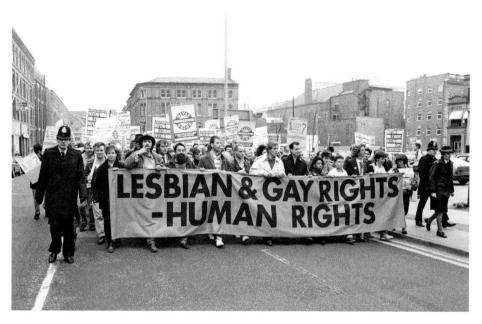

▲ 20 February 1988. Protestors at an anti-Clause 28 rally.

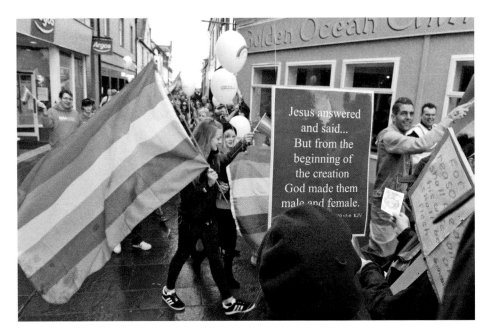

▲▶ 6 October 2018. Locals and supporters take to the streets of Stornoway for Pride Hebrides, the first LGBT+ Pride march in the Western Isles. The event was met with protest from concerned church groups.

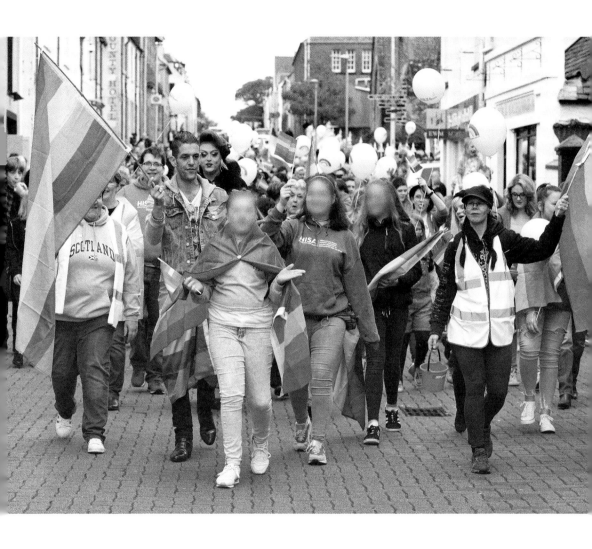

'DEEDS NOT WORDS': THE SUFFRAGETTES

As the twentieth century dawned, women's lives in the UK were changing. Women could now own property, secure a divorce and keep custody of their children, and go to university.

However, they still couldn't vote. And this showed no signs of changing.

Frustrated, Emmeline Pankhurst formed the Women's Social and Political Union (WSPU), a militant splinter group of the National Union of Women's Suffrage Societies, which were seen as too calm and too slow. The WSPU – also called the 'suffragettes' – certainly couldn't be accused of *that*. They began a campaign of direct action, heckling politicians, chaining themselves to fences and burning down buildings. When they were arrested, they went on hunger strike and endured force-feedings.

After a pause in the campaign during the First World War, their efforts finally paid off: on 14 December 1918, women who were over the age of 30 and owned property could vote. Ten years later, this law was amended to anyone of any gender over the age of 21.

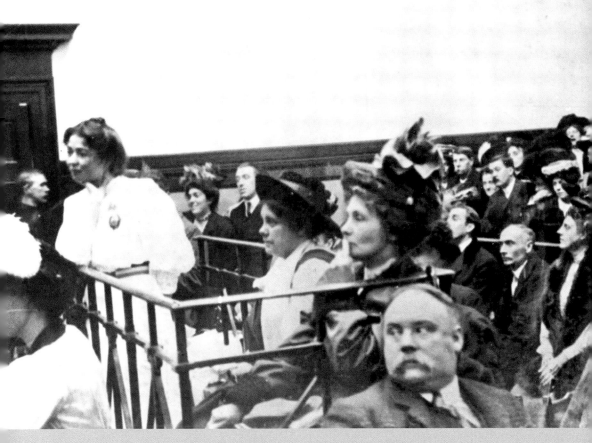

▲ October 1908. A suffragette in the dock at Bow Street police station, London.

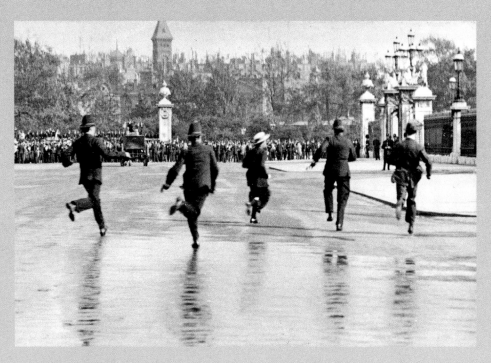

▲ 22 May 1914. Suffragettes trying to raid Buckingham Palace to present a petition to King George V.

➤ 16 February 1909. Muriel Matters in the basket of an airship with a megaphone as suffragettes attempt to disrupt the State Opening of Parliament by showering politicians with leaflets. Unfortunately, it didn't work: due to the airship's weak engine, they couldn't reach Westminster and instead landed in Croydon.

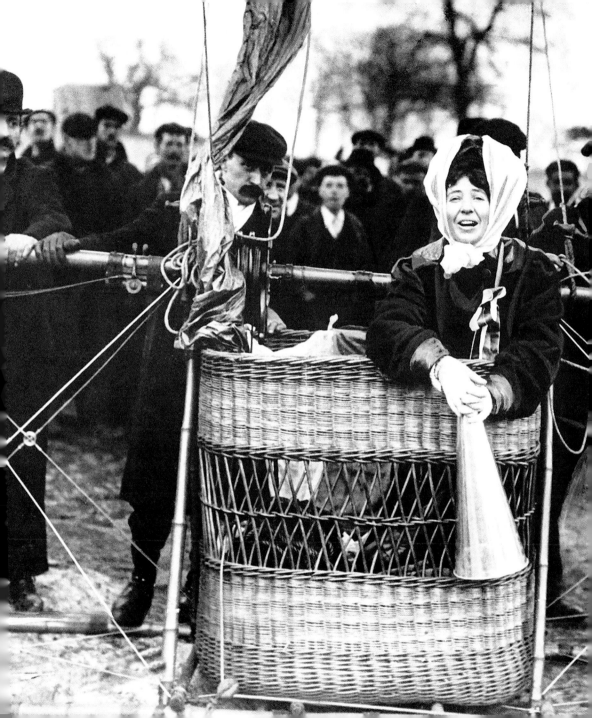

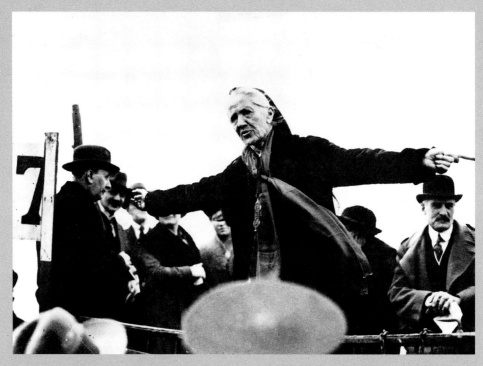

▲ 2 May 1920. Suffragette Madame Despard speaking in London's Hyde Park on Labour Day.

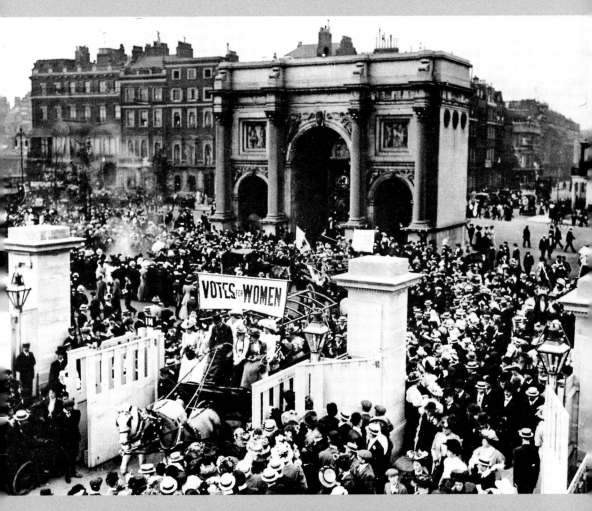

▲ June 1908. Suffragettes at a Votes for Women meeting in London's Hyde Park, attended by 250,000 men and women, entering the park by the Marble Arch entrance.

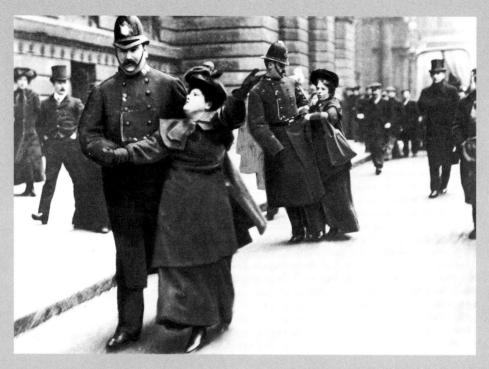

▲ 10 May 1906. Suffragettes under arrest and being escorted by policemen in London.

➤ 21 May 1906. A suffragette demonstration.

'DEEDS NOT WORDS': THE SUFFRAGETTES

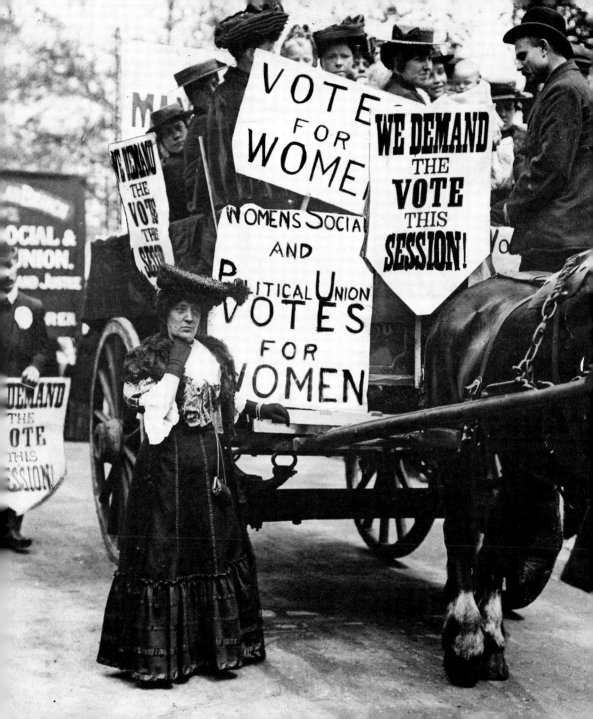

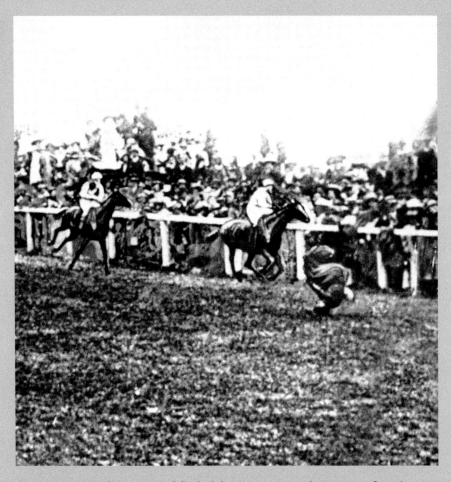

▲ 8 June 1913. Emily Davison is killed while trying to stop the victory of racehorse Anmer – owned by King George V – during the Epsom Derby. Davison, one of the most prominent members of the Suffragette movement, threw herself under the animal's hooves and died as a result of her injuries. It is unknown if this was her intention.

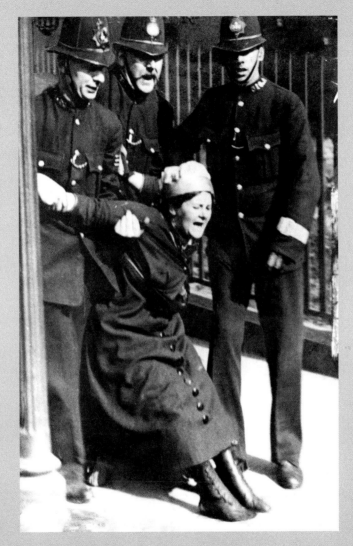

▲ 1912. A suffragette being restrained by three policemen.

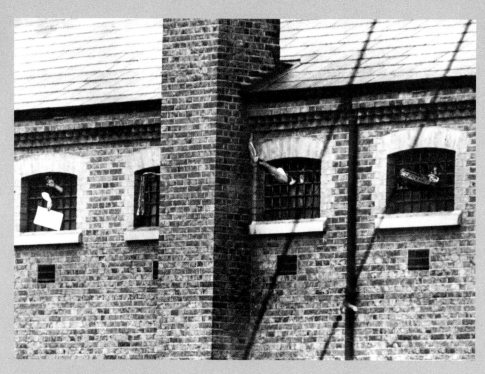

▲ 1909. Suffragettes in their cells at Holloway Prison, London, waving through the bars.

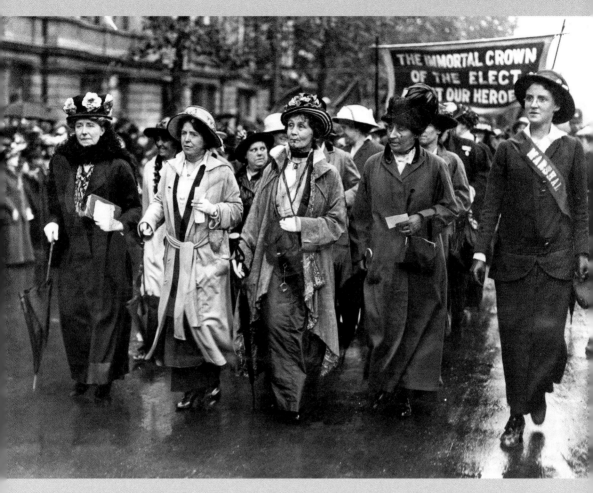

▲ 17 July 1915. The leader of the WSPU, Emmeline Pankhurst (centre), leads a procession along Victoria Embankment, London, to demand that the government use women for ammunition production during the First World War.

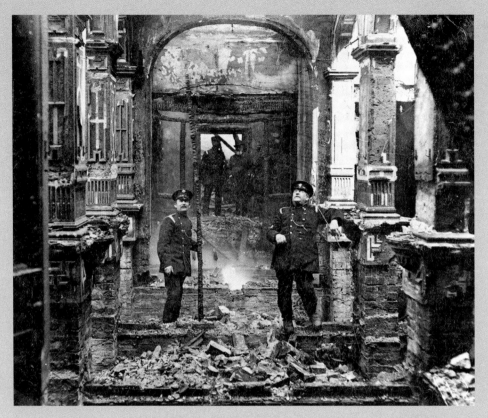

▲ 15 April 1913. The aftermath of a suffragette arson attack: Levetleigh, a house near Hastings that was owned by anti-suffrage politician Arthur du Cros, was set fire to by suffragettes during the night. The fire brigade, called at about 3 a.m., were still at work at 9 a.m., by which time the mansion was destroyed.

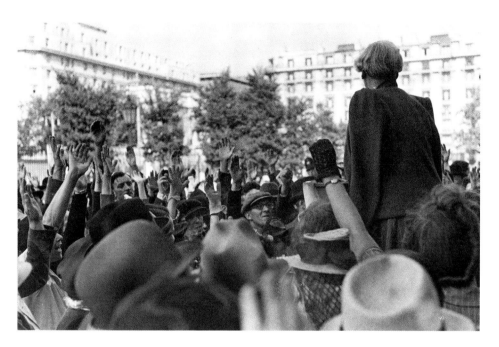

▲ 16 August 1942. Women for Westminster Movement rally at Hyde Park Corner in London. The speaker has just asked the crowd to raise their hands for equal pay for men and women.

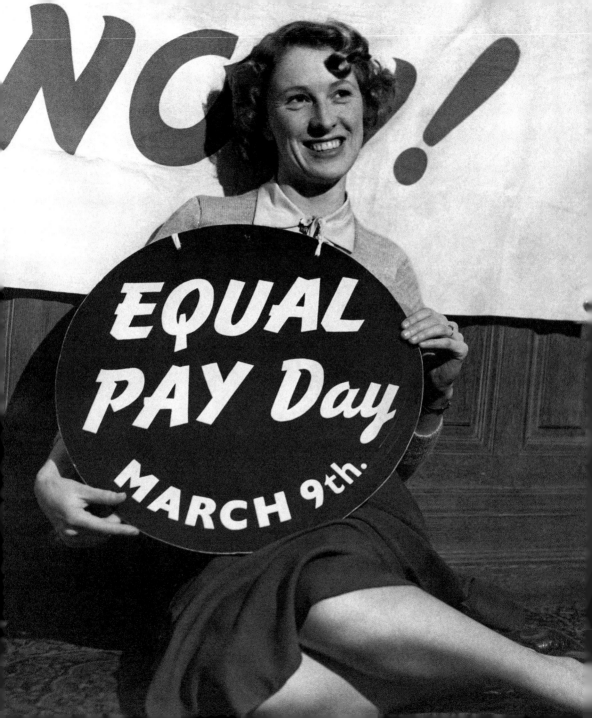

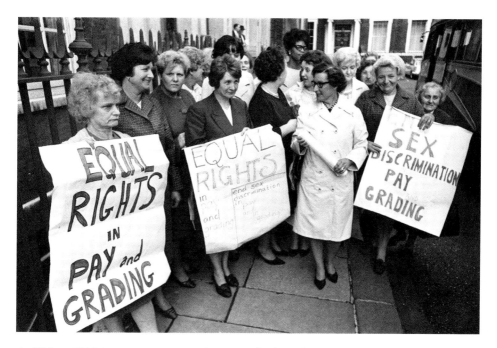

▲ 28 June 1968. Women sewing machinists with placards and banners outside the offices of Barbara Castle, Secretary of State for Employment.

Sewing machinists at the Ford Motor Company plant in Dagenham walked out of their workplace on 7 June 1968 to protest being downgraded to 'lesser-skilled work' and receiving only a percentage of what 'lesser-skilled' men earnt. Their strike caused the entire plant to grind to a halt, although it still took three weeks to negotiate a settlement of 92 per cent of what the higher-skilled men were paid. Their strike was one of the key factors that led to the Equal Pay Act 1970.

◄ 2 March 1954. Isobel Sheer of Curzon Street, Glasgow, who has been elected 'Miss Equal Pay' by the Civil Service Council.

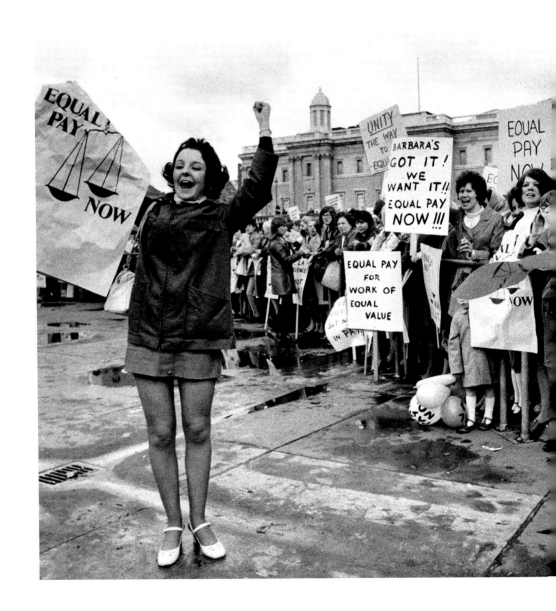

◄ 19 May 1969. A thousand women and girls on a march demonstrating for equal pay at Trafalgar Square in London.

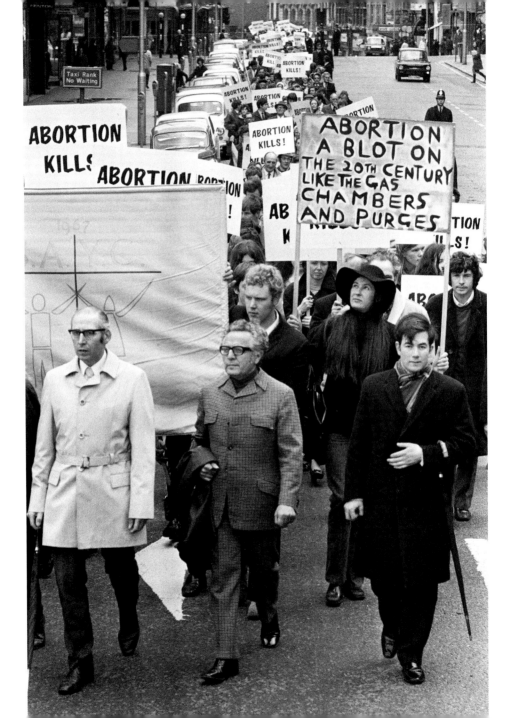

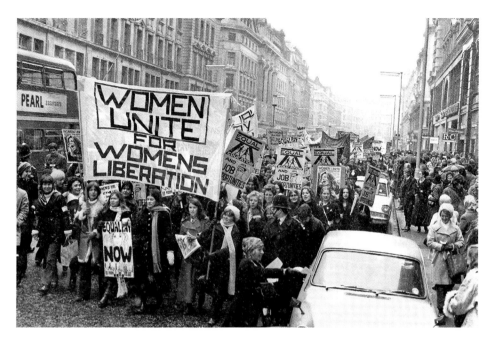

▲ 6 March 1971. Snow falls on hundreds of members of the Women's Liberation Movement as they march through London. The biggest all-female demonstration since the days of the suffragettes was demanding equal pay and job opportunities, free contraception and abortion on demand, amongst other things.

◄ 20 June 1971. Around 5,000 men, women and children, led by Leo Abse MP, march through Birmingham city centre to protest against abortion.

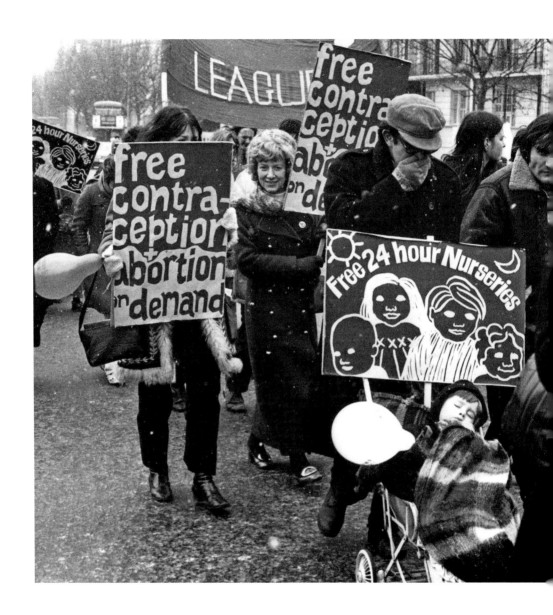

◄ Caught up in a blizzard, the WLM marchers defy the bitter cold on their way to Trafalgar Square, London. One youthful demonstrator decides to go to sleep in her pram.

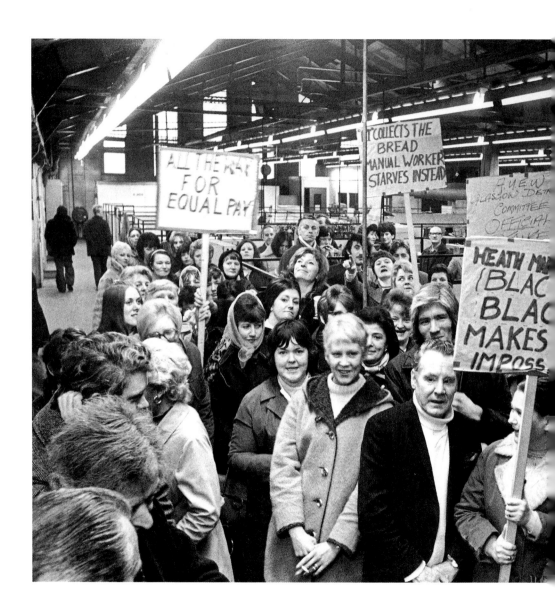

◄ 12 December 1973. Women taking part in Scotland's first sit-in for equal pay get ready for day two of their revolt, armed with books, knitting and flasks of tea.

'I can't believe we still have to protest this.'

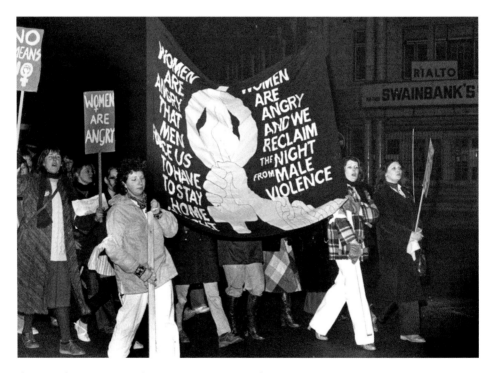

▲ 6 April 1979. Liverpool women protesting violence against women.

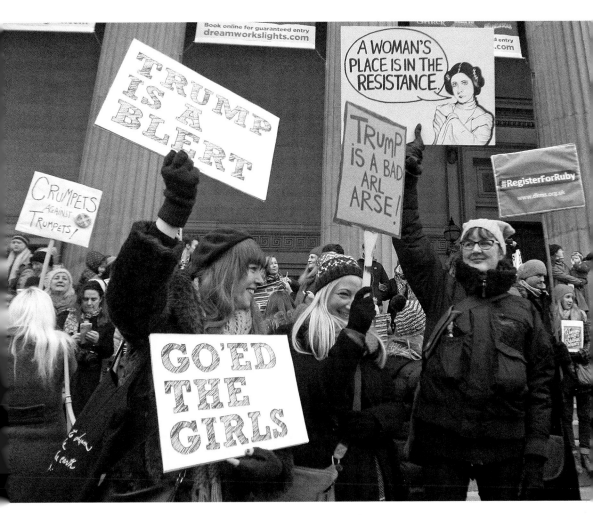

▲ 21 January 2017. Liverpool Women's Rally outside St George's Hall.

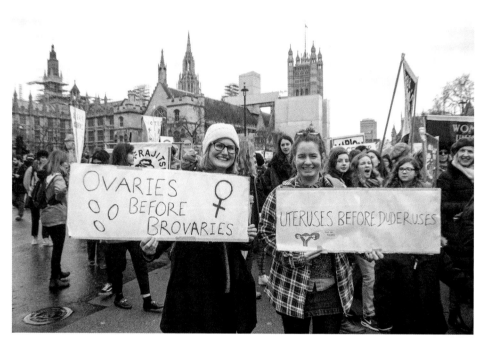

▲ 4 March 2018. March4Women in Central London.

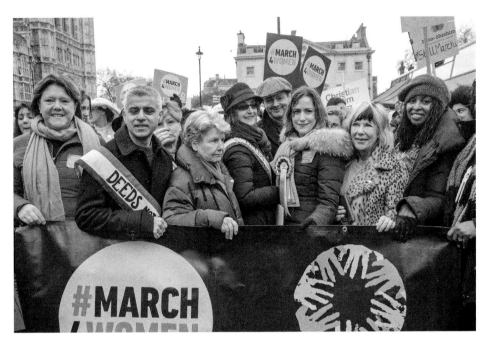

▲ 4 March 2018. Maria Miller MP, Sadiq Khan, Sandi Toksvig, Michael Sheen, Victoria Atkins MP and Dawn Butler MP lead the March4Women outside the Houses of Parliament.

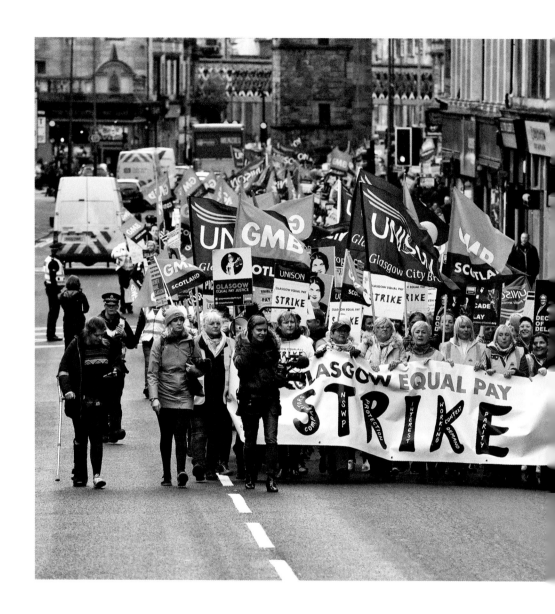

◄ October 2018. Glasgow City Council workers from the GMB and Unison unions marching for equal pay.

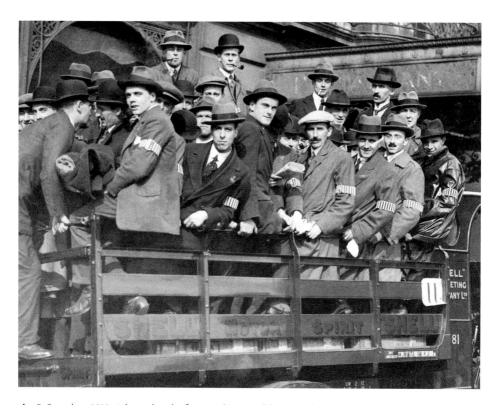

▲ 5 October 1919. A lorry load of special constables who have been called up to guard the power station during the 1919 Railway Strike.

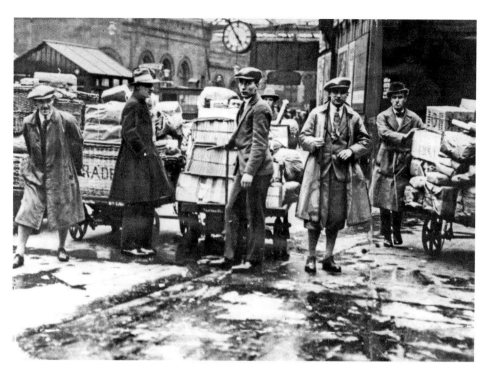

▲ May 1926. Volunteers help move parcels at Newcastle Central Station during the General Strike of 1926, where some 1.7 million workers went on strike for nine days.

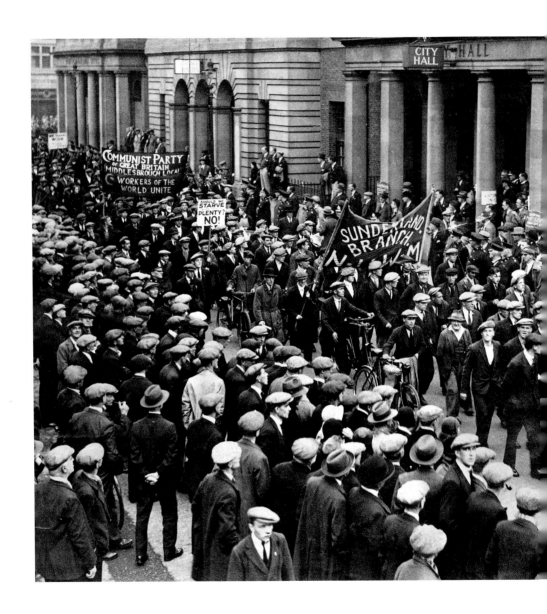

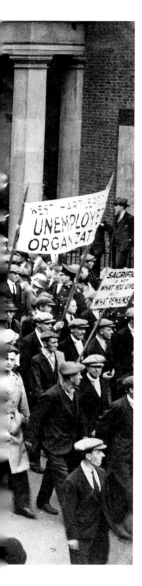

◀ 6 September 1932. Unemployed marchers, including Lancashire mill strikers and communists from London, march outside Newcastle City Hall, where the Trades Union Congress was in session. Among the procession were men who had walked from as far away as Middlesbrough and West Hartlepool; some had even collapsed on the way.

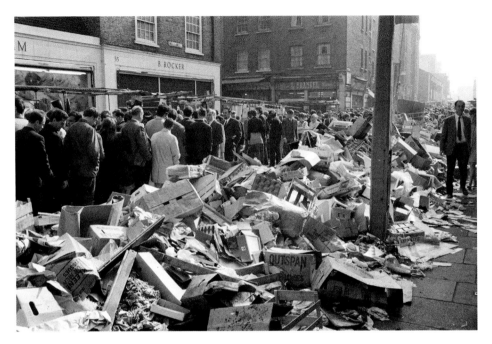

▲ 5 October 1969. A dustmen's strike leads to huge piles of rubbish in Petticoat Lane, London. The market carries on as usual, but there are dustmen pickets to make sure that nothing is removed.

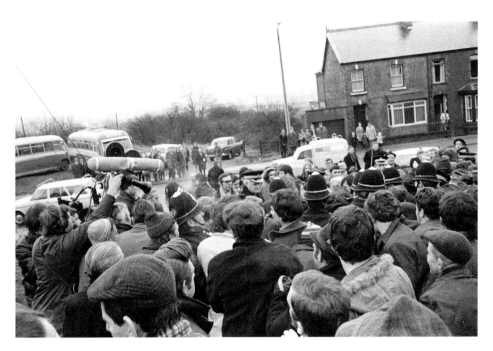

▲ 26 January 1972. Coal miners clash with National Coal Board office workers outside the Coal Board Office in Tondu, Mid Glamorgan, Wales.

THE MINERS' STRIKE

On 6 March 1984, the National Coal Board announced that the agreement reached after the 1974 strike had become obsolete. They intended to close twenty coal mines, which would result in a loss of 20,000 jobs and devastate many communities.

On 12 March, Arthur Scargill, president of the National Union of Miners (NUM), declared that strikes in the various coalfields were to be a national strike and called for strike action from NUM members in all coal fields. On 22 March the strike was made official – it would grow to be one of the most violent industrial disputes in British history, with frequent clashes between not only miners and police, but also strikers and strike-breakers. The strike ended on 3 March 1985, nearly a year after it had begun.

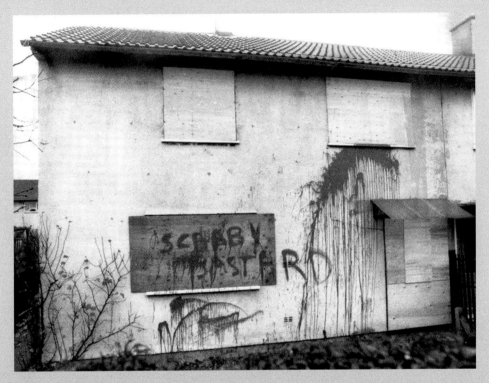

▲ 4 December 1984. 'Scab': a strike-breaking miner's house, boarded up and daubed with red slogans, in South Yorkshire.

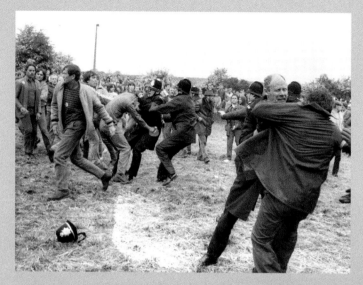

▲ 1 June 1984. Police and pickets clash at Orgreave coking plant near Sheffield.

▶ 29 May 1984. An injured police officer is helped to safety by ambulance men in protective clothing at Orgreave coking plant.

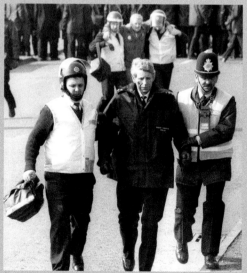

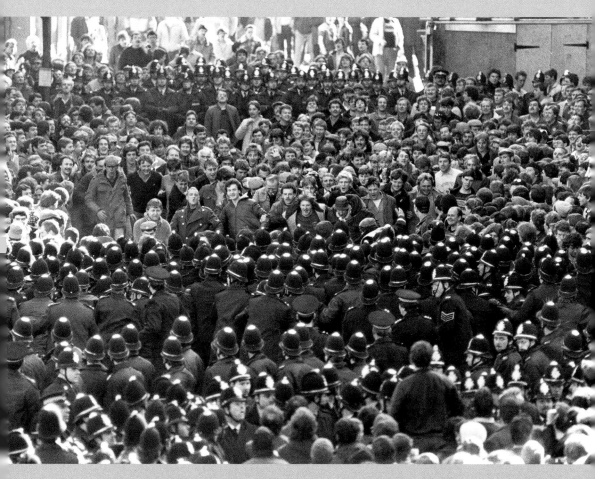

∧ 12 April 1984. Police and pickets, face to face.

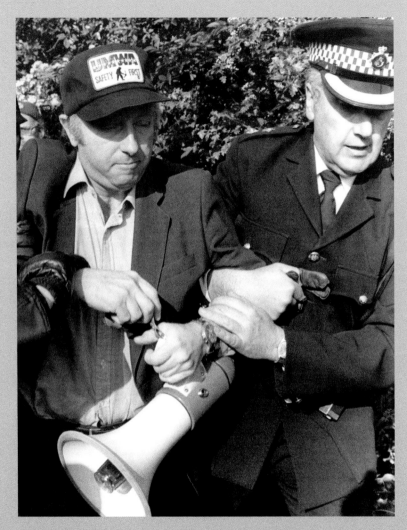

▲ 30 May 1984. Arthur Scargill is arrested on the picket line as he leads thirty pickets towards the gates of the Orgreave coking plant.

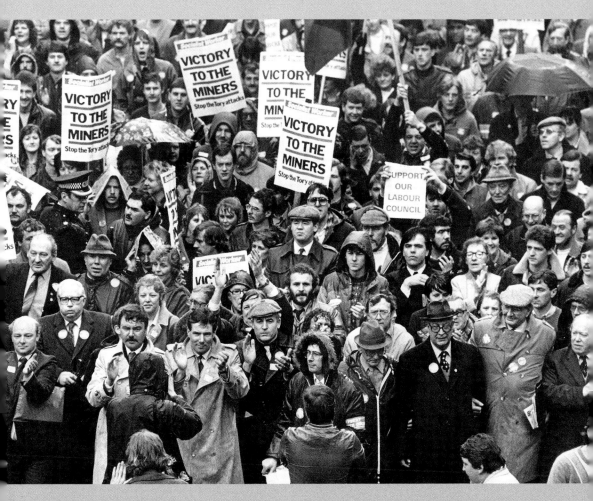

▲ 29 March 1984. Labour's Leader and Deputy Leader of Liverpool Council, John Hamilton (third from right) and Derek Hatton (seventh from right), lead 50,000 marchers prior to the council meeting at the town hall to support the Labour group deficit budget proposal. However, no budget from any party gained a majority.

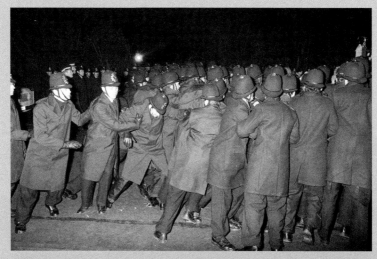

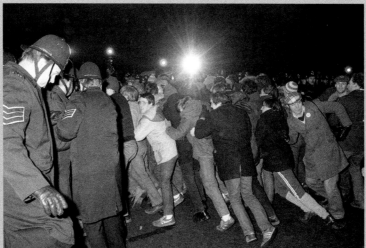

▲➤ 27 March 1984. Pickets and police clash at Daw Mill Colliery, near the village of Arley, Warwickshire.

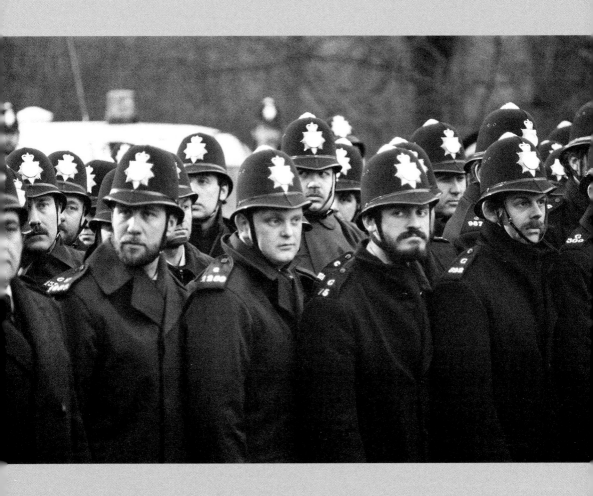

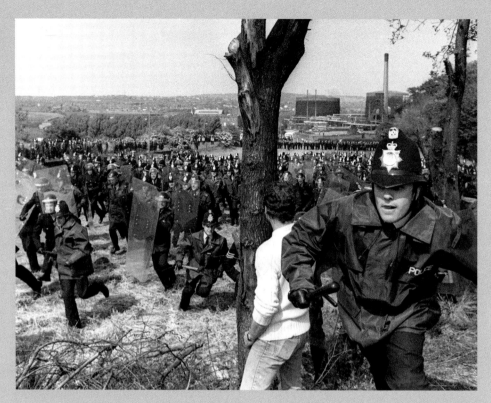

▲ 18 June 1984. Police charge pickets outside the Orgreave coking plant.

Thousands of striking miners picket outside the Orgreave coke works, where they were met by huge lines of police who had been brought in from all around the country. The miners wanted to stop lorries loaded with coke from leaving the plant for the steelworks, as they thought that would help them win their strike, and help protect their pits, their jobs and their communities. The police were determined to hold them back.

The Battle of Orgreave was the turning point in the year-long miners' strike of 1984. It was the moment the police and government's strategy switched from the defensive (protecting collieries, coking plants and working miners) to the offensive (actively breaking up crowds of pickets and arresting large numbers of strikers).

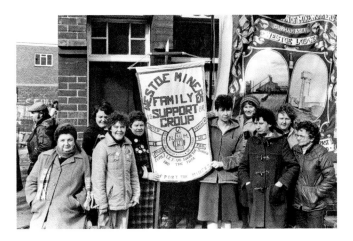

▲ 5 March 1985. A peaceful march by striking miners and the Westoe Miners' Family Support Group.

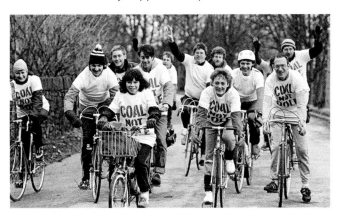

▲ 2 February 1985. Pedal power is harnessed to help the families of striking miners. More than twenty cyclists took part in a sponsored ride organised by Meltham Miners' Support Group. The 41-mile route started at Denby Dale station and took in nine pits in West and South Yorkshire before finishing at Barnsley.

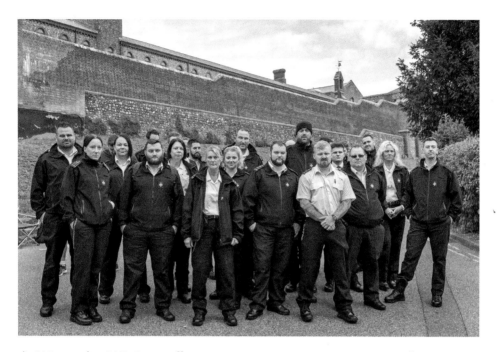

▲ 14 September 2018. Prison officers at Lewes Prison, East Sussex, stage a walk-out over unprecedented levels of violence by prisoners.